ON
DIVORCE

Portraits and voices of separation
A photographic project by Harry Borden

Published in 2023 by The School of Life
First published in the USA in 2024
930 High Road, London, N12 9RT

Copyright © The School of Life 2023

Photography © Harry Borden
Designed and typeset by Marcia Mihotich
Printed in Lithuania by Balto Print

A proportion of this book has appeared online at
www.theschooloflife.com/articles

Every effort has been made to contact the copyright holders of the
material reproduced in this book. If any have been inadvertently
overlooked, the publisher will be pleased to make restitution at the
earliest opportunity.

The School of Life publishes a range of books on essential topics in
psychological and emotional life, including relationships, parenting,
friendship, careers and fulfilment. The aim is always to help us to
understand ourselves better – and thereby to grow calmer, less
confused and more purposeful. Discover our full range of titles,
including books for children, here: www.theschooloflife.com/books

The School of Life also offers a comprehensive therapy service,
which complements, and draws upon, our published works:
www.theschooloflife.com/therapy

www.theschooloflife.com

ISBN 978-1-915087-39-3

10 9 8 7 6 5 4 3 2 1

ON
DIVORCE

The School of Life

INTRODUCTION

1.

Everyone wants to talk about weddings (especially the table plans and the speeches); few can bear to consider divorce. Like death, divorce happens somewhere far offstage, an unmentionable and fear-inducing rebuke to all that we would want to believe of ourselves and the dangers we face. Those who go through divorce typically have a double burden to bear: the turmoil of the event itself and, no less profoundly, a blanket societal embarrassment about its meaning. The revelation of an impending divorce tends to generate near-funereal silence and mumbled, quasi-censorious 'I'm so sorrys.' Because love is the meaning of modern existence, what could there possibly be to say to those who – perhaps with a joint mortgage and two children in tow – have seen no option but to break their vows?

Yet to those who know them from up close, divorces are simultaneously the most appalling and, at moments, the most creative, idealistic, rejuvenating, thought-provoking and plain mesmerising events they will ever go through. Pretty much any other drama will forever pale in comparison. Years after, divorce will still loom as the defining indentation and inflection point in their lives. No story of divorce, properly told, can ever be unengaging or banal. These are the moments in which we catch the human animal in all its complexity, turmoil, folly and beauty.

Insofar as we have narratives of divorce, they tend to be fictional ones: novels and films do the lion's share of the telling. Therefore, there may be a particular role for divorce as seen through the lens of the harder, more concrete medium of documentary photography, a medium that can – with urgent literalness – collar us emotionally, as

if to say, 'This truly does happen to people like you and me: ordinary types, neither exceptionally beautiful nor ugly, sane nor mad, good nor evil – alive right now, in a street much like yours.'

The faces and voices that follow are a mirror that can help to correct some of what we think we know of divorce. Stock images of divorcees tend to skew in stereotyped directions: we picture reprobates and sinners, cads and bounders, mid-life adulterers and abandoned paragons. We can be quick to drain the humanity from those who offend (what can still count as) our dominant moral code. The portraits that follow – captured over a two-year period by the photographer Harry Borden (himself divorced) and spanning cultural, ethnic, class and age lines across the United Kingdom – pull us in a different direction: towards compassion and identification, curiosity and self-reflection, challenge and empathy.

Few of us are without some relationship to divorce: we may be the children, parents or grandparents of divorcees, the colleagues or friends; this may be what we went through a decade ago or what lies ahead of us in the 2030s; it might be what we are just concluding – at this very moment and in intense turmoil – or something that we will need to set in motion in the coming days. Divorcees are, like all of us, only grown-up children, stumbling in the dark, trying to make sense of their choices, beset by blind impulses, illuminated by occasional grace, and human – all too human. One of the best things we can do in the face of our difficulties is to turn pain into art – of a sort that others can refer to, at moments of particular isolation and befuddlement, to recover their poise and sense of community. This documentary project insists that divorce should never be thought of as shameful, morally simple, abstract or even necessarily tragic. It is as much a part of who we are as love.

To understand why divorce exists, we have no option but to return, of course, to the reasons for marriage. The old motives – the ones that held firm across the globe for most of the history of humanity – tend to no longer apply. We rarely marry to please our parents, to appease the gods, to satisfy a dynastic claim or to unite our strip of land with a neighbour's plough or an ox any more. We marry – to wield a consequential and fateful term – 'for love'.

Quite what this should mean takes us back even further, to the pleasures and hopes of early childhood. Babies who are loved cannot in any way spell out the grounds for their delight, but their entire adulthoods will be shaped by their experience of luxuriant care. Someone is profoundly delighted that they exist. The person keeps planting warm, reassuring kisses on their brow. They feed them soft, interesting foods cut into manageable portions. They worry about the sunlight that might be hurting their eyes. They hold them in soft arms. They bathe them in warm water. They hold them up and smile broadly and beatifically. They satisfy their emotional and bodily needs, attenuate their fears and give them constant reasons to feel content in their own skin.

At the heart of what we crave in adult love is a return to some of these early feelings. It is no coincidence that lovers at the height of joy should so regularly turn and call their partners 'baby'. We may not, as adults, want exactly the same treatment, but we crave the essence of what a happy infant enjoys. We want our cries to stir others' care and worry. We want to know that we matter primordially to someone else – and that they are sure to come when we weep and panic in the night. We want to feel we can delight them when we smile. We may receive money and acclaim from strangers, but unless

we benefit from this kind of close-up care, nothing will ever quite feel meaningful or right.

It may seem as though 'love' was invented by film or chocolate box companies, but it has far more tenacious roots in our personalities than that. We are built to be thrilled by someone who takes an interest in our concerns, who enquires into the details of our days, whose hands can lie softly on our worry-knotted foreheads and who can pull us away from our tendencies to melodrama and exaggeration.

Long before there was ever any thought of divorce, the baby in us had some very powerful longings to know that they mattered.

3.

Unfortunately, few of us know how to love. After all, no one ever teaches us. At school, we are expected to excel at trigonometry, the twelve times table and the relationship between France and England during the Hundred Years' War, but no one ever enquires how sound we might be around the topic of offering affection or regulating the moods and pains of another. We tend to assume that love is a natural reflex, like sneezing, rather than a skill that might in some ways need to be learnt, like playing the violin or landing an airliner in the dark in a forty-mile-an-hour crosswind.

We head out into the adult world without any detailed impression of the gravity of what emotional life will ask of us. We assume that it must be enough to have an impressive career, a pleasant personality or a svelte appearance.

We start to make costly errors. We don't realise that we aren't in fact very good at listening and that every time someone makes a realistic remark about our behaviour, we respond in a defensive manner that can end up sinking the spirits of anyone who cares

about us. We don't notice our rigidity and fear around accepting warmth. We have no awareness of how we might be using work, our phones or our hobbies to deny opportunities for intimacy. We assume that we might be relatively easy to live with and that any fault must lie entirely with our exes, who we speedily and gleefully dismiss as 'toxic' or 'narcissistic', much to the approbation of certain friends who are more interested in kindness than truth.

Our responses are conditioned by early childhoods which we may have left radically unexplored. Like baby ducklings, we are imprinted without any awareness of the scripts we're following. We blindly look out for people who are going to frustrate us, we make a beeline for inappropriate types and we are hidden masters at spoiling kindness and sound intentions. We exercise a relentless appetite for suffering and a submerged compulsion towards meanness. We don't notice our distinctive manner around sex, the particularities of our routines or our secret reserves of anger and vengeance towards a parent or caregiver that we may be projecting onto innocent adult suitors.

Our capacities end up sharply at odds with our hopes. We are as enthusiastic about the idea of love as we are unpractised at its nurture and safe and kindly exchange.

4.

We are also, much to our cost, extremely impatient. We simply cannot bear that we may need to continue to be on our own for a few more months or years or even decades before a compatible partner appears. We hallucinate an answer that may not be remotely there. We fail to exercise a semblance of the due diligence that we would expend on buying a house or a pair of socks. We don't send ourselves

or our prospective partners to a psychologist for a battery of tests, six months of examinations or an MBA-style course in the mechanics of love. We fall into a manic hurry to be legally recognised, fed perhaps by a background anxiety about having made an erratic choice. We decide to get married after two weeks and our friends and families declare us 'romantic' (one of the most dangerous words in the lexicon) rather than in flight from open-minded thoughtful exploration. We spend months planning a wedding and minutes wondering about a marriage's real chances of success.

Society gives us little help with our frenzy. It conspires to render life for the single particularly bereft and isolating. It leaves us thinking that, given our age, there really can be no alternative but to join all the others with their weekend ceremonies. No one tells us quite loudly enough that the best – and perhaps only – assurance of a healthy marriage is a bold indifference to spending the rest of our lives by ourselves.

5.

Once a divorce has occurred, we often ask at what point it 'began'. What we can bet is that there is almost always a large gap between the moment when divorce is spoken about and when the fuel for it started to accumulate. Its origins may lie with certain initially minute fissures that will have lain ignored, possibly for decades.

Historians know all about the challenges of chronological pinpointing. It is common to ask when a cataclysmic event like, for example, the French Revolution began. A traditional response is to point to the spring of 1789, when one of the orders of the Estates General took an oath to remain in session until a constitution had been agreed on, or a few weeks later when a group of Parisians

stormed the Bastille prison. But a more sophisticated and instructive approach locates the beginning significantly earlier: with the bad harvests of the previous ten years, with the loss of royal prestige following military defeats in North America in the 1760s or with the rise of a new philosophy in the middle of the century that stressed the idea of citizens' rights. At the time, these incidents didn't seem particularly decisive; they didn't immediately lead to major social change or reveal their solemn nature, but they slowly yet powerfully put the country on course for the upheavals of 1789: they moved the country into a revolution-ready state.

Likewise, divorces tend to begin long before the moment when one party sits the other down at the kitchen table and declares that they have had enough. They begin after certain conversations that didn't go well in a bathroom three summers previously or after a sulk in a taxi home five years before.

A timeline of the true causes of divorce might look like this:

Unending busyness: It was a Sunday morning, our beloved had been occupied for months with a big project and we'd been very understanding. Now it was over and we were looking forward to some closeness and a trip to a café. But there was suddenly something new that they needed to look at on their phone. We glanced over at their face lit up by the glow of the screen; their eyes looked cold, determined and resolutely elsewhere. Or else they hatched a sudden, firm plan to reorganise the kitchen cupboards just when at last we might have had some quiet time together in the park.

Neglect: We were away on an exhausting trip and, in a break between meetings, we leapt at the chance to call them. They picked up, but the television continued on in the background. They had even forgotten

we'd had to give a speech and it felt a little humiliating having to remind them and hearing their lacklustre 'great' in response.

Shaming: We were with some new friends – people we didn't know too well and wanted to make a good impression on. Our partner was looking to amuse them and, having cast around for options, opted to tell everyone a story about how we once showed the wrong slides in a presentation at work. They know how to tell a good story and there was a lot of laughter.

Entitlement: Without discussing it, they arranged that we'd both go and have lunch with their parents. It wasn't so much that we minded going, it was the fact that they didn't feel the need to ask us if we minded and if the timing was convenient. On another occasion, without even mentioning it, they bought a new kettle and got rid of the old one; it was as if we had no say at all. Sometimes they'd just tell us what to do – 'take the bins out', 'pick up some mineral water at the shop', 'put on different shoes' – without adding 'please' or 'would you mind' or 'it would be lovely if …' Just a few words would have made a very significant difference.

Flirting: We were at a party with them and we saw them across the room: they were bending towards this person, saying something; they were laughing charmingly; they put their hand on the back of the other person's chair. Later they said it had been a very boring conversation.

One too many arguments: It wasn't the basic fact of having disagreements, it was the sheer number of them – and their unending, repetitive nature. One that sticks in the memory was when we were

at the seaside and things should have been happy for once – and yet they chose once again to ramp up the tension about a Thai takeaway that had been ordered. We remember arguing and, at the same time, one part of our mind disassociating, looking down upon the two of us standing on the pier with cross faces and wondering 'Why?'

Lack of tenderness: We were walking in the street together near the antiques market and we reached out to hold their hand, but they failed to notice; another time, they were doing something at the kitchen table and we put an arm round their shoulders and they said sharply, 'not now'. In bed, we're always the one to turn towards them and kiss them goodnight; they respond, but they never, ever initiate. This rankles more than it seems normal or possible to say.

Erotic disengagement: There was a sexual idea we'd been getting interested in but we felt awkward about mentioning it to them. We tried to give a few hints, but they didn't give us the impression they were curious or encourage us to expand. Instead, they gave us the sense that it would be a lot more convenient if we just kept whatever it was that tickled us to ourselves.

Individually, none of these things may be very dramatic. Some little version of one or another of them may be happening pretty much every day for every couple. And it's not all one-way: both parties are probably doing some of these things quite regularly, without particularly noticing or meaning to.

Yet a careful historian of divorce might point to any one of these as the moment at which – in a true sense – a split began: a feeling was implanted deep in someone's mind (perhaps beyond the range of their conscious awareness) that there was something utterly

critical missing in their relationship and that they could not endure its lack forever.

It is common, when a divorce is called for, to become an inquisitorial prosecutor: to seize a phone and ask the 'cheat' or the 'deserter' in detail where they have been; to read through their emails and parse every receipt. But such assiduousness is a little late, a little misdirected and rather too self-serving. The divorce didn't begin with any dirty texts or lunch appointments; it began on a sunny, innocent afternoon many years before, when there was still a lot of goodwill, when a hand was proffered and the partner was perhaps fatefully careless about how they received it. That might be a rather more painful account of our relationship and its troubles than we are ready to contemplate for now, but it may also be a more accurate and, ultimately, more useful one.

6.

How might we spot a couple headed for divorce – even if, or especially if, that couple might be us?

Having arguments does not, in itself, say very much about the likelihood of a relationship disintegrating. What matters is how arguments are interpreted, conducted and resolved. The fragile unions aren't necessarily the ones in which people shout, insist that this is finally it, call the other a ninny and slam the door; they are the ones in which emotional disconnection and rupture are not correctly identified, examined and repaired.

A number of qualities are required to ensure that a couple know how to successfully navigate conflict and discord. There is, first and foremost, the need for each party to be able to pinpoint sources of discomfort in themselves early and accurately: to know how to

recognise what they are unhappy about and what they need in order to flourish in the couple. This is not necessarily as obvious as one might imagine. It can take time and psychological insight to know that it was actually the missing phone call or the request to move the date of the holiday that was really the source of anger.

Then there is the equally vital quality of feeling that each has the right to speak; that they aren't duty-bound to be 'good' and not cause trouble; that it is acceptable to say when they are miserable and when something – however small it might appear – is troubling them; that it is better to spoil a few evenings than ruin a marriage.

It can help to have a sanguine assessment of how human relationships tend to go: to accept that a bit of disappointment and some friction belong to the necessary ingredients of good-enough love, that it isn't a disaster to be cross at points and seemingly convinced that this should be the end.

A subsidiary talent is the skill of knowing *how* to speak up. It might not be exactly at the moment the problem appears; diplomatic skills matter. We might need to wait until some of the surface tension has dissipated; perhaps the next morning can do just as well. We need a background confidence in order to not blurt out every objection in a panicked diatribe or shout a wounded feeling across the room when the other is themselves too upset to hear it. We need to know how to formulate our complaints into a convincing, perhaps even comedically framed point that has a chance of winning over its target.

It matters in all this that we feel both attached to the partner and, at the same time, have an active impression that we could walk away from them were matters to ever truly escalate. Feeling that we have options, do not therefore have to cling to the other and instead deserve good treatment ensures that our voice can be measured and that the status quo will remain manageable.

None of these factors tend to be present in those unfortunate couples who do not just argue but lack the gift of arguing well. A range of inner obstacles prevents them from dealing effectively with their emotional disconnection and anger:

Over-optimism about relationships: Paradoxically, fragile couples tend to be very hopeful about love. They associate happiness with conflict-free unions. They do not expect, once they have found the person they unwisely see as The One, to ever need to squabble, storm out of a room or feel unhappy for the afternoon. When trouble emerges, as it inevitably does, they do not greet it as a sign that love is progressing as it should, but rather as alarming evidence that their relationship may be illegitimate and fundamentally flawed. Their hopes tire them for the patient tasks of diplomatic negotiation and routine maintenance.

Out of touch with pain: Fragile couples tend not to be good detectives of their own sufferings. They may be both unhappy and yet unsure as to the actual causes of their dissatisfactions; they know that something is wrong in their union, but they can't easily trace the catalysts. They can't zero in on the fact that it was the lack of trust in them around money that rankles or that it has been the other partner's behaviour towards a demanding youngest child that has been hurting. They lash out in vague or inaccurate directions, their attacks either unfairly general or unconvincingly specific.

Shame: A shamed person has fundamental doubts about their right to exist: somewhere in the past, they have been imbued with an impression that they do not matter very much, that their feelings should be ignored, that their happiness is not a priority and that

their words do not count. Once they are in a couple, shamed people hurt like anyone else, but their capacity to turn their hurt into something another person can understand, and be touched by, is recklessly weak. Shamed people will sulk rather than speak, hide rather than divulge, feel secretly wretched rather than candidly complain. It is frequently very late – far too late – by the time shamed people finally let their lovers know more about the nature of their desperation.

Excessive anxiety: Complaining well requires an impression that not everything depends on the complaint being heard perfectly. Were the lesson to go wrong, were the other to prove intransigent, we could survive and take our love elsewhere. Not everything is at stake in an argument. The other hasn't ruined our life. We therefore don't need to scream, hector, insist or nag. We can deliver a complaint with some of the nonchalance of a calm teacher who wants an audience to learn but can bear it if they don't; we could always say what we have on our mind tomorrow, or the next day.

Excessive pride: It takes an inner dignity not to mind too much about having to level complaints about things that could sound laughably 'small' or that leave us open to being described as petty or needy. With too much pride and fear, it can become unbearable to admit that we have been upset since lunch because our partner didn't take our hand on a walk, or that we wish so much that they would be readier to hug us last thing at night. We have to feel quite grown up inside not to be offended by our own more childlike appetites for reassurance and comfort. It is an achievement to know how to be strong about our vulnerability. We may have said, rather too many times, from behind a slammed door, in a defensive tone, 'No, nothing is wrong

whatsoever. Go away,' when secretly longing to be comforted and understood like a weepy, upset child.

Hopelessness about dialogue: Fragile couples often come together with few positive childhood memories of conversations working out: early role models may have simply screamed and then despaired of one another. Those in fragile couples may have never witnessed disagreements eventually morphing into mutual understanding and sympathy. They would deeply love to be understood, but they can bring precious few resources to the task of making themselves so.

None of these factors mean that there will have to be a divorce, but they are generators of the states of emotional disconnection that contribute to an all-important divorce-ready state. Outwardly, things may be seemingly well. A couple may have an interesting social life, lovely children, a new apartment. But a more judicious analysis will reveal an unexpected degree of risk: in the circumstances, whatever it may seem later, a separation won't be just an idle self-indulgence or a momentary piece of selfishness. It will be the result of identifiable long-term resentments that a couple, otherwise blessed and committed, lacked the inner resources and courage to investigate.

7.

One of the standard things we might hear, when someone explains to us why they left their partner, is: 'We hadn't had sex for years.' This plea picks up on the basic notion that a key sign of the health and viability of any marriage lies in the frequency of sexual contact between its participants. The end of sex must therefore legitimately and necessarily signal the end of love.

But if we lift the lid on what sex actually means, we might conclude something a little different. Suppose we ask the bizarre-sounding question: why do we actually want sex? The ordinary answer is that we want it for pleasure and excitement. But this might not, in fact, be very accurate about our true aspirations. There are lots of sources of pleasure. A less familiar but deeper answer may be that really, via sex, we are seeking proof of affection and enthusiasm. When we're rebuffed sexually, the pain isn't just that we won't be having physical intimacy with a person; it's that we are being given a sense that they don't particularly like us. The sting is to our sense of lovability rather than just to our nerve endings.

So we could say that, under the surface of bitterness about sex, it's never just how much sex is going on that matters, but how much affection, tenderness, interest and warmth is being demonstrated. Sex is operating as a proxy measure, but it's not in itself the thing that truly counts. We could easily imagine having a lot of sex without love – and suffering. Or being loved deeply but, for whatever reason, not having much sex – and being content.

This helps us put a more accurate finger on when a lack of sex should realistically become a matter for dissent or a parting of ways. Insofar as an absence of sex is independent of any shortfall in love, we might stay. Insofar as it is further evidence of a decline and absence of love, we could be following the logic of the heart to leave.

8.

The world often explains the cooling of desire that takes place in many couples as a sheer and inevitable result of exposure. It is, they say, typical to sexually neglect a person who is always around. But the

true reasons seem more complicated, more psychologically rich and, in their own way, a lot more hopeful.

If we stop desiring, it is seldom because we are bored or because it is 'normal' to take someone for granted; it is chiefly only because we are, at some level, *furious*. Anger creeps into love and destroys admiration. We cease to delight in our partner because we unknowingly grow entangled in various forms of unprocessed annoyance. We can't look at them with longing because, somewhere deep inside, we are inhibited by trace memories of certain let-downs, large and small, of which they have been guilty without having been informed. Perhaps they caused us immense difficulties around a work crisis – and never apologised. Maybe they flirted with a friend of ours – and left us feeling tricked and unsure. They may have booked a holiday without asking us – and then insisted that they'd done nothing wrong.

Every infraction was not, on its own, necessarily particularly serious, but taken cumulatively, a succession of minor disappointments can acquire a terrible capacity to dampen and ultimately destroy ardour. Yet it is not the simple fact of being let down that counts very much – the true problem is created when there hasn't been an opportunity to process our disappointment. Irritation is only toxic when it hasn't been extensively and thoughtfully aired.

Perhaps we tried to explain what was wrong but we got nowhere. Our partner lost their temper and we gave up. Or, more subtly, we might have felt unentitled to make a fuss over so-called 'small things' and therefore stayed silent, even though, in our depths, the small things mattered immensely to us. With great unfairness to our partner, we may have forgotten to admit to our own sensitivities even as we developed a steady burden of resentment against their unknowing offences.

What follows from buried anger is something that can be mistaken for disinterest, but is, in substance, very different. We no longer want to celebrate their birthday, we withhold sexual attention, we don't look up when they walk into a room ... This could seem like the normal impact of time and proximity, but it is not. It is evidence of cold fury. We do our anger an honour, and can start to dismantle its deleterious impacts, when we recognise the full impact of unexamined frustration on our emotions. We never simply 'go off' people; we only ever get very angry with them. And then forget we are so.

To refind our instinctive enthusiasm for our partner, we need to accurately locate our suppressed distress. We have to allow ourselves to be legitimately upset about certain things that have saddened us and properly raise them – for as long as we need to – in a way that lets us feel acknowledged and valued. Because anger inflicts an ever-increasing toll the longer it is left unaddressed, a good couple should allow for regular occasions when each person can – without encountering opposition – ask the other to listen to incidents, large or small, in which they felt let down of late. There might be an evening a week left free for this form of 'processing'. The mission should be bluntly known to both parties: *an opportunity to pick up on areas in which we feel let down* – not, one should add, in the name of killing love, but of ensuring its ongoing buoyancy. It goes without saying that we might not immediately see why a given thing should matter so much to our partner, but that isn't the point. The objective of the exercise should never be to listen to complaints that seem utterly relatable to us; it should be to let our partner know that we care that these are problems in their minds.

To ensure that our desire never suffers, this kind of hygienic ritual might be placed at the centre of every relationship. If couples too often ignore the requirement, it is because they operate under an

unfair burden of bravery: they are far more susceptible than they let themselves think. They assume that it cannot be sane to get 'upset' so often, to experience so much hurt, to be so easily ruffled. They can't summon the courage to make a complaint about things that they don't even admit to themselves have caused a sting – and so stay silent until it is no longer possible for them to feel. Wiser couples know that nothing should ever be too small to cover at length – for what is ultimately at stake in a marathon conversation about a single word or a miniscule event in the hallway can be the fate of the entire relationship. These lovers are, in this sense, likewise parents who, when a child is sorrowful, are patient enough to enter into the imaginative realm of the child and take the time to find out just how upsetting it was that the felt-tip pen smudged the top of the drawing of the daffodil or that their teddy bear, Nounou, didn't get to eat 'lunch' at nursery. In a similar spirit, it might not be silly at all to devote three and a quarter hours to understanding why a partner became silently and immensely upset by the way we said the word 'ready' to them at breakfast the day before or how it felt to them when we were a touch slow at laughing along with a mildly unfunny story they shared at dinner with our aunt about a train and a suitcase. The gratitude that will flow from such an effort to understand them will be amply repaid the next time we feel abandoned because they forgot to put the lid back on the olives or omitted a second 'x' at the end of an email.

To complain in love is a noble and honourable skill very far removed from the category of whininess with which it is sometimes confused. The irony of well-targeted and quickly raised complaints is that their function is entirely positive. Honesty is a love-preserving mechanism that keeps alive all that is impressive and delightful about our partner in our eyes. By regularly voicing our small sorrows and

minor irritations, we are scraping the barnacles off the keel of our relationship and thereby ensuring that we will sail on with continued joy and admiration into an authentic and unresentful future.

<div align="center">9.</div>

The world does not think especially well of an urge, in love, to try to alter our partners. We can expect a good deal of sympathy for complaining, at the end of a relationship, that our ex didn't accept us for 'who we truly were'. There can be few more damning remarks to make of someone than, 'They tried to change me.' We equate true love with a wholehearted compliance to our natures as these presently stand.

The longing is wholly understandable – and yet entirely unreasonable. Viewed dispassionately, none of us should ever insist on remaining exactly as we are given the amount of folly, immaturity, blindness and egoism that are in all our characters. Universally, we should be graciously willing to be nudged – with kindness and compassion – to become someone slightly different.

Some of us can, on a good day, bear to take this awkward truth on board. We can stand that someone else might have noticed an excess or a lack in a part of our make-up; we do not have to immediately accuse them of ingratitude or meanness for finding fault with us. We don't have to be perfect in their eyes to remain tolerable in our own.

But divorce rates are so high in part because listeners are so few. Wherever there is a break up, we can be close to certain that – somewhere along the line – there will have been a doomed attempt by one person, usually over many years, in both calmer and noisier ways, to change another. Someone will have wanted their partner to

be more open or more restrained, more creative or less chaotic, better at disciplining the children or less impatient and authoritarian, and will have said so on the plane to the foreign city, in the kitchen in the early hours or in bed on a scratchy Saturday morning. And – to the despair of the complaining party – these sincere attempts at reform will have ended in considerable bitterness and anger. Someone will have half-listened to the request and replied, 'The problems aren't all mine,' 'What about you?,' 'Get off my case' or 'Why can't you love me as I am?!'

More than any other factor, it is closed-off defensiveness that erodes trust and funds lawyers' offices. There is almost no limit to the problems we can put up with so long as a partner remains somewhat willing to listen to our complaints and promises that they will do their best to change where and as they can. 'I hear you …' must be the single most romantic sentence that could ever pass a partner's lips. 'I'm going to try to become someone different' has a magical capacity to throw the most strident break-up into reverse.

A melancholy aspect of any split is a confrontation with the idea of how difficult it is to change anyone. People do, of course, change, but almost never quite when and as we would want them to. They change when we no longer really care, or when we're not looking or when we've chosen something else to feel desperate about. Or after we have died. This fixity undermines any faith in the power of language, dialogue and logic. We could put together the most impressive and rigorous arguments as to why this or that path would be preferable, we might try humour and charm, a hotel by the seaside or dinner in a revolving rooftop restaurant, but fine prose and delicately couched proposals will be nothing when they come into contact with our brains' calcified architecture. We might develop an eloquence greater than Tolstoy's and a way of presenting our case

more seductive than Montaigne's or Plato's and yet still be powerless before a lover who looks at us with boredom and puzzlement and responds, 'Well that's how you choose to see it; it's not really how it seems to me.'

These partners are not merely being obtuse. We may simply have the wrong picture of change in mind. We might naively imagine it to be akin to some basic physical movement, like raising a glass of water or crossing a room. We fail to assess the sheer arduousness of psychological evolution. It might be as difficult for someone to start to show more affection when we return home from work or to be a bit less patronising towards us in front of the children as it would be to ask them to learn Mandarin on command or climb a Himalayan peak in their bedroom slippers. 'Why can't you just …' is an eminently plausible aspiration and, at the same time, a psychologically entirely childlike one too. We forget, in our impatience, that it may have taken twenty-five years to mould a partner into who they are today; their way of speaking and reacting, though it can appear light and optional, may in its essence be as solid as concrete, the fruit of long, complicated and definitive fashioning at the hands of parents and circumstances far outside of our purview.

Every divorce, beneath the surface, will contain a failure of change. We wanted them to evolve and they didn't. We put it nicely and they didn't care. We should not be indefinitely surprised at this. We might have judged it an easy business to become a little bit more emotionally open or a touch more confident with strangers, but in the end, such things may be immeasurably harder than to dissolve one's assets, traumatise one's offspring, sell a house, buy two more properties, relocate the children to another part of the country, split a pension, sell a business, find another partner and remake one's life. There might be nothing harder, rarer or more beautiful than to be

able to listen to a complaint from someone who cares deeply for us, to see the pain and longing in their eyes and to do our best to work out, without pride or irritation, how to become someone slightly different in the name of love.

<div align="center">10.</div>

As the inevitability of divorce starts to become apparent, there is likely to arise – in the minds of one or both parties – a thought as hopeful as it is energising and enchanting. Perhaps, despite all the discord and pain, all the late-night discussions and fraught negotiations, the divorce does not – after all – need to be a nightmare. Because they have known each other so long, because there are children, because there is still a residue of great affection and loyalty between the couple, perhaps they will be able to pull off something that 'the others' – blunter, more stupid and coarser types – seem never to manage. They will not be like everyone else, they will honour their love *by remaining friends*. They will be kind, they will resist the lure of hatred, they will not squabble over money or bicker over who gets the sofa or the wine. Not for them the typical vulgar acrimony and name-calling of lesser beings. They may have failed at love, but they will not fail at divorce.

But then something surprising is likely to start happening. The couple will realise that their studious attempts at friendliness are proving quietly crushing. Those warm hellos, those joint appearances at dinners, those family weekends away, those polite enquiries about work, all threaten to dishonour the nature of the cataclysm that has undeniably befallen them: two people who, at the start, aimed at something grand, intimate, passionate and authentic have decided to die apart. To be a civilised good friend does not do

justice to what the relationship tried to be. It can be kinder, truer and more real to hurl insults and stick pins in voodoo dolls than to lapse into tepid 'niceness', that final insult we reserve for those who don't properly matter to us.

Furthermore, kindness is in danger of keeping us stuck in an eternal no man's land. If we do truly get on as well as we are saying, if it's still possible to chat and go on holiday together as though nothing has happened, why is divorce even on the agenda? Why would we take the trouble to legally untangle ourselves from someone with whom we love to watch television or discuss the progress of the plants in the garden? Then again, as we also recognise, we have been betrayed, we do want to call an end to this fraught and collapsed union, we do need to go through with the break, because the emotional impasse is sizeable and our misery beyond doubt.

Given such dilemmas, it is extremely helpful that lawyers should exist. Lawyers do kindly and civilised divorcing couples an immense service: that of shaking them from their sentimentality and blind generosity and allowing them at last to hate – and therefore, to be free of one another. Without these aggravators of conflict, couples might be forever orbiting one another, never able to let go, drawn back together by the gravitational pull of familiarity and loyalty. But with lawyers to hand, whatever the initial vows, couples are guaranteed to receive a superlative education in how to despise and make a fresh start.

The fees will be so enormous that it won't be possible to read an invoice without cursing the name of the person who made them necessary. Thanks to lawyers' guile, we will start to feel passionately attached to issues we had no idea we cared about. It will suddenly seem immensely important that we hold on to the car or don't have to surrender the photo albums. There will be cathartic struggles over

who gets to spend Christmas where and what should be done with the shares from Mum and Dad. The children's entire inheritance will be spent in one gleefully catastrophic month of arguing over who keeps the television. Lawyers will ensure that their clients will always be appropriately incensed, that goodwill will be constantly ignored and that areas of conflict will be meticulously stoked.

It won't be possible, when the lawyers are done, to stand in the same room as one's ex without shuddering and loathing. This is the person who tried to separate us from our blender or tried to leave us without a beach hut or pension. There truly can be no hope of reconciliation now. We won't be going on holiday with them again; we won't be making a joint appearance at a friend's 40th any time soon. We hate them and wouldn't be sad if they died. Legal processes are to separations what weddings are to marriages: ceremonial, overly expensive rituals that bind us to our wishes and concretise our intentions.

It sounds miserable, but it is not. Lawyers do us an enormous favour. Over the course of a split, they will have cost us everything – but they will have drawn us back from one gigantic troubling possibility: that of becoming fond of one another again … when perhaps we really shouldn't. They will have helped to convince us of what might otherwise always have been in doubt: that we did a difficult but ultimately very necessary thing.

11.

Those who go through a divorce routinely report that the event was so seismic, a part of them died in the process. They are no longer the people they once were. A new version of themselves – more sober, older, deeper – was forged in the white heat of the separation.

What are the ways in which a divorced person qualifies as a distinctive kind of being? What does divorcing do to our souls?

Grief: First and foremost, divorce makes us sad, probably sadder than we will ever have been. The person we imagined we would be closing our days with has gone, and it feels like a death. Someone who was as much a part of 'reality' as the sun and the trees has forever disappeared, and we lose our balance. If this can happen, the most solid-seeming parts of life can no longer be relied upon. Such thoughts lie heavy on us; it can be hard to get through a light-hearted sentence without being pulled back for another pass across the landscape of misery. We might cry 'for no reason at all' at the many haphazard moments when the contrast between what existed then and what is present now come to the fore. We remember the holidays we took at this time of year; a smell carries us back to a perfume they wore or a dish they cooked; we wonder what they might be doing now, at 5.30 p.m. on a Sunday, when we would so often lie in their arms and look for reassurance for the week ahead.

Suspicion: That our trust in love and human nature should have been so badly violated renders us intensely suspicious of anyone else who crosses our path, promising us a better outcome. Our very attraction to them makes us prone, after we have let ourselves believe in them for a while, to moments of violent rejection: how dare they promise us something that may not work out? What impudence for them to expect us to believe in what they say.

We may not be very easy propositions. We're not doing it on purpose, but we are covered in scars. We leave dates early. We cancel arrangements at the last minute. We end certain promising new relationships very quickly. We both want love and are terrified of it.

We darkly suspect the worst at every moment. When is the axe going to fall? When will we discover another affair? When are they going to start to be stubborn and unreasonable? We lose faith in the entire species: can anyone be trusted? Does affection ever last? Has a sane human ever been born?

We would so like to fall in love again, but we also know that to undergo the pain we went through would be more than we can remotely envisage. We would rather be on our own until eternity than be torn apart again. We are almost pleased when a suitor loses interest or calls for more space. We have loved too much to dare to suffer again.

Friends: We will have profoundly shocked many in our social circle. The divorce won't have felt like our business alone; it will have been experienced as a challenge, a rebuke or a violation to all those couples we got to know together and who helped us to define our sense of normality. Their ongoing togetherness casts doubt on our choice; our break-up asks questions of their marriages. The reasons for the awkwardness are real: both sides are in a struggle to work out what is normal or good. No one who is married is without some thought, however fleeting, that they should be apart. No one who has divorced is without a comparable inkling that they might have stayed together. Both parties are struggling to remember what they want and how they should live.

Growth: Marriages allow us to atrophy in the direction of our partner's strength. They are brilliant at taxes, so we stop filing our returns ourselves. They're great at cooking, so we stop doing much in the kitchen. They're brilliant at making money, so we let our professional skills lapse. We forget the most basic of things. We don't know how

bus passes work any more. We have no idea how to turn up the heating. We'd be far too shy to make a speech at a dinner.

Divorce will let us have none of this. We have to become – with some urgency – competent across all areas. This isn't the time or place for fragility or regression. There are potentially children to look after and a small business to run. So divorce finds us on the floor in the garage changing a tyre, back in the office in a suit doing a presentation or in the kitchen wearing an apron preparing the children's tea – unfamiliar routines that bear the imprint of the departed partner's strengths.

For the first time in a while, we have the sensation of being whole adults once again. We can no longer be baby-fied by 'Mummy' or 'Daddy'. It is terrifying, but energising, too. There is a real sense of achievement when we finally work out how to open the tin of tuna or calculate the month's expenses. If we can succeed at all these until-recently insuperable tasks, then so much more could be possible for us.

Lessons in bravery: We may have spent our life hitherto as people-pleasers. But now, perhaps, we did something a little shocking and, in our small community at least, revolutionary. We dared to trust our instincts. We took our emotions seriously. We put our own happiness first. We learnt to be selfish, at last.

If we have children, we will undoubtedly have set them back in various ways. We'll have made them wonder if they deserve to exist when those who created them can no longer bear each other's presence. But we'll also, along the way, have gifted them something very precious: an example of how good and meek people can, when it becomes necessary, change their lives in the name of greater freedom and possibility. The divorce will have been a lesson in how to not

always submit; we'll have empowered our children to know, thirty years from now, that if they were ever to end up in unjustified misery, they too could gird themselves and leave. Or be left – and survive.

Authenticity: One of the big goals of life – in which divorce can play a central contributing part – is to try to align what is going on for us on the outside with who we are on the inside. The alignment tends to start off very askew. Our school friends don't really understand what we love and we are too scared to tell them. We pick up a job for money without probing too much into how well matched it is with our genuine interests. We might get into a relationship with someone who can't sympathise with our passions.

But if our lives go moderately well, we can hope – with time – to correct at least some of these misalignments. We can learn to tell people what we like and who we are. We can stop smiling when we don't find anything funny. We can start to earn money in ways we respect. We can stop seeing people who our families or universities pushed us together with arbitrarily – and find our own tribe.

However difficult it is, divorce may be – when we look back on it – a critical step in this process of learning to become who we are. We might, when younger, simply not have known how, or have dared, to be with someone who could sympathise with and encourage our most authentic tendencies. We may have to divorce to stop betraying ourselves.

12.

What separates divorcing couples from married couples is ultimately the degree to which they believe in happiness. Despite the gloominess to which they condemn themselves to dwell in for a time, divorcees

are passionate visionaries when it comes to happiness. They truly believe that the purpose of life is to attempt to be happy – rather than to try to maintain their financial security or please the neighbours.

Those who get divorced aren't the most miserably married. They are those with the greatest belief that misery can be overcome. Those who remain in couples may do so not because they love one another particularly, but because they don't much believe that two people can bring each other profound satisfaction. They stay together because they suspect that all the hullabaloo wouldn't in the end do very much for them; because they don't believe in love.

You have to have a lot of faith in humanity to call up the lawyers. You have to be a robust idealist to split apart a gloomy family. Divorce constitutes the ultimate triumph of hope over experience. But, if we were to make no more than a minimal case for the act, we might say that, even if we do not end up much happier afterwards, divorce will at least have helped us to make a change in the sort of topics and issues we will suffer over. We won't have to complain for another thirty-five years about this or that matter that has wracked us incessantly since the wedding. We'll be able to find something else to regret and something fresh to fantasise about. Divorce will give us the immense opportunity to be unhappy in new, and perhaps more interesting and more challenging, ways. And that might – just at a minimum – be all the rationale we ever need to explore the act or to reconcile ourselves with humour and compassion to its initially daunting presence.

THE PHOTOGRAPHS

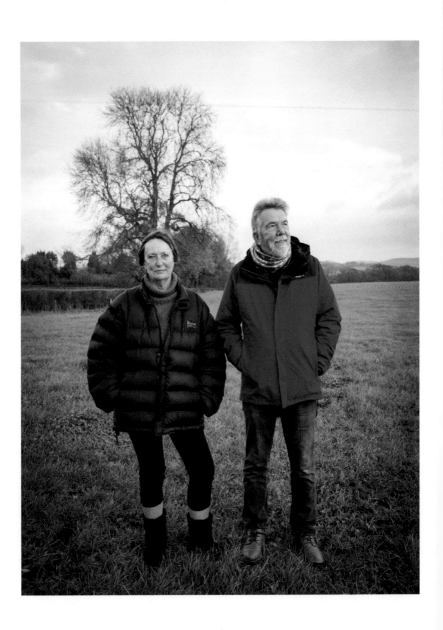

JONATHAN AND HILARY

JONATHAN: I was with Hilary for eleven years. It was a tender and very happy relationship. But I happened to meet Angie – and I simply fell in love.

Breaking up was the hardest thing, it was terrible. I felt so guilty. I was brought up to be honest and reliable, but I betrayed her badly, and that's hard.

I'm really pleased that Hilary moved on and found somebody else and is happy. But what I'm most pleased about is that we remain good friends – I think there's a depth of affection there that will never go. If you love somebody and have a deep bond with them, it's forever.

HILARY: I never stopped loving Jonathan. But I realised eventually that he had fallen in love with someone else, so it was just not going to work with us being together. With time, I realised that even though I missed him, he hadn't died. So, there was no reason why I couldn't carry on seeing him! There are no rules for these things. Every divorce is as unique as the people involved in it!

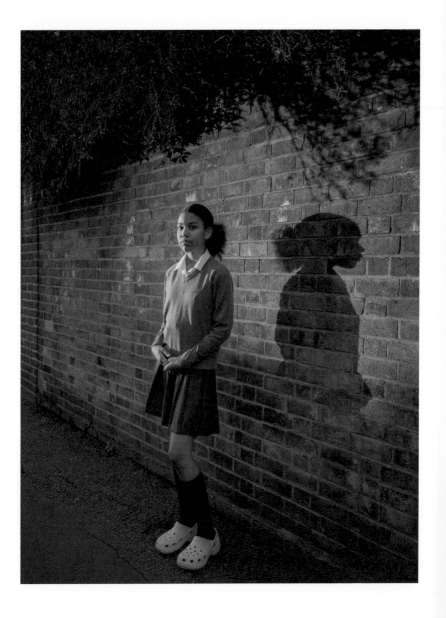

ZARAH

They split up right after I was born so I can't ever remember them being together. They strongly dislike each other now. The insults don't stop. It's strange that I'm the product of two people who more or less can't be in the same room together. And yet here I am: one whole person out of these two angry halves.

I envy other people. How easy it is for them. They don't have to think 'Oh it's my birthday. Do I want to spend it with this parent or that one and whose moods do I have to manage this time?'

My mum is very talkative. We go deeply into things. My dad, not so much. We go out a lot but we don't talk. Mostly he's very jokey with me. He has lots of nicknames for me, like 'Zazillah' and 'chicken doo doo face'.

They both used to say a lot of awful things about one another. Now, neither says anything, but one argument can send everything into orbit. I hope to do things very differently.

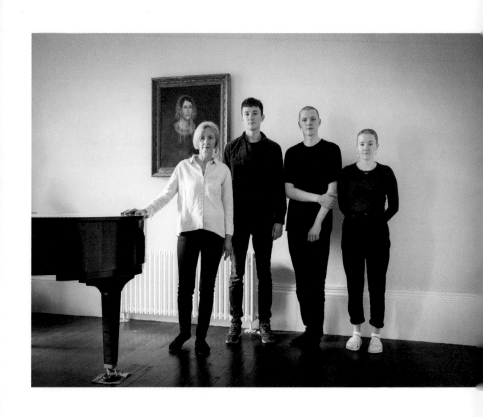

ANNETTE

(with Alastair, Mia and Celia)

My parents split up when I was two and I had a very disrupted childhood. As I grew up, all I wanted was to have a happy, settled family life.

When I first met Julian, I fell for his kindness and his sense of freedom. I knew that we were totally different but when you're young, you think you're invincible. But increasingly it became obvious that we had very little in common. We didn't like seeing the same friends and had no pastimes we enjoyed together. He became more eccentric and, I suppose, I became more conventional.

It was Julian who made the first move. It was the divorce from hell – and tough on the three children. He told me that he didn't mind if I got a boyfriend – and that he might find a partner for himself. The divorce took three years. I became quite ill during it.

Sadly, Julian died a few weeks after Harry took the photo. He and his wife spent his last Christmas with us, and we all played games together and shared lunch on Christmas Day.

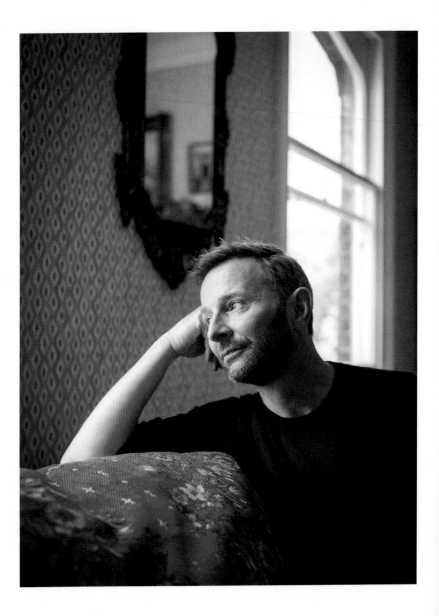

JEREMY

I had mostly dated men before I fell in love with my ex-wife. I was very open about it and so I didn't have to be secretive about my past with anyone.

After we divorced, I only had relationships with men. I am clearly more gay than straight. Although I've never felt the need for my sexuality to be categorised.

Perhaps it was easier for my ex-wife that I only dated guys after we split up. It's not for me to say. I think she was more interested in the type of person I chose rather than their gender.

I didn't plan to be married again, but here I am. So, I've been married to a woman and now I'm married to a man. Some find it confusing. I just feel incredibly lucky that I have them both in my life.

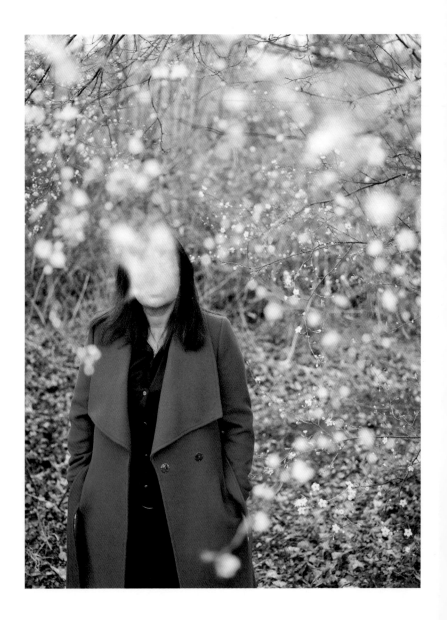

MAYA

He was drinking more and more alcohol to manage his anxiety but was highly functioning. It's something I kept hidden as I loved him. There is so much shame attached to addiction, especially within my community. Our daughter was increasingly feeling anxious, and I sought counselling for her through her school. It was gut-wrenching to learn that she told the counsellor: 'Mum's always crying' and 'Dad's always drinking.'

One day he collapsed on the stairs and our daughter started to help me take his shoes off. In that moment, I thought: 'What the hell am I teaching my daughter?' I don't ever want her to be in a relationship in the future where she is in my position. I felt I had inadvertently played my part in normalising an unhealthy relationship. I realised I had to remove us both from this home environment.

I hope that one day she will forgive me for my mistakes and for breaking up her entire world. She adored her dad and loved us both but has had to navigate these two separate worlds since our divorce.

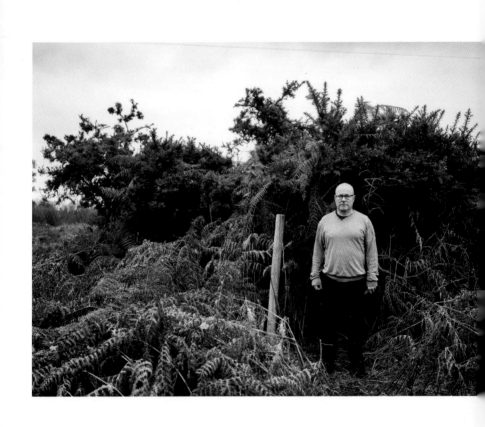

KEITH

I guess she fell out of love with me, and I didn't realise it. We'd been together nine years and had two kids. We'd broken up once already – before the children were born, for about three months, and then got back together. She can be restless.

She left me for somebody else. She's still with her partner, they got married a year after. They're probably better suited than we were.

As break-ups go, it was relatively easy. The kids went to her – the car would be tuned to Radio 4 and when they came back it would be tuned to Radio 1. My relationship with her now is pretty much non-existent. It's an occasional, 'We must catch up sometime.' But I'm too tired to catch up with her. I think how she dealt with it was cowardly, but whatever… I didn't linger on it at the time, and I certainly don't linger on it now. Love is a strange thing.

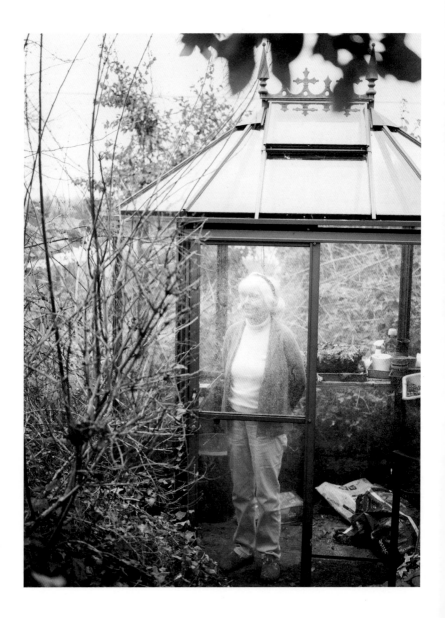

SARAH C

I was thrilled my son was getting divorced. His wife loathed me from the word go. I wasn't used to being loathed. At first, the idea of him marrying her, I thought that was super – I liked the idea very much. I had a wonderful mother-in-law so I never envisaged that things could go wrong. They married but I could feel that things were not good. I asked her if she'd call me by my first name and she said, 'I can't because we're not friends.' She had a template that she put me into where she thought I was a boring, country lady. When she finally left, I asked him 'If I had voiced my doubts would it have made any difference?' and he said 'No, none'. During the time I knew her, I didn't get anything from her, not even a bunch of flowers.

I liked his new wife from the word go. She's particularly nice, very friendly and supportive.

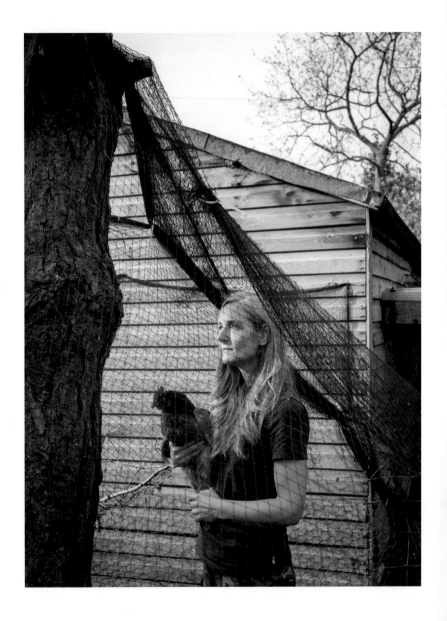

LESLEY

Marriages: I've had a fair few. My first marriage was really wonderful. It lasted, from wedding to divorce, for twenty-two months. I was so in love. And then one day I no longer was. He took it reasonably well – and even helped me to move into my new flat.

I went pretty much from one to the other. Number two was the total opposite, and we had many, many happy years. And many not so happy years. The best thing that came out of that marriage was my eldest son.

With the third marriage, I was asked to sign a prenup, which I had no issue with, as his mum has money, which I wasn't after. When our marriage was at the point of breaking down, we tried therapy for eighteen months, but it was no good. You can compromise, but being happy is in the end what's really, really important.

I don't regret any of my marriages. But I do question my reasons for getting married. I think everyone should have one-to-one therapy – there's so much to learn. I'm still at the beginning.

I'm now in a very grown-up, loving, stable relationship. He's an amazing man. I think when you get older your reasons for getting married are completely different. When you're young it's like you're looking for somebody who's genetically compatible perhaps to have children. But later on, you're looking for somebody who's fun and can make you laugh, and I definitely have that.

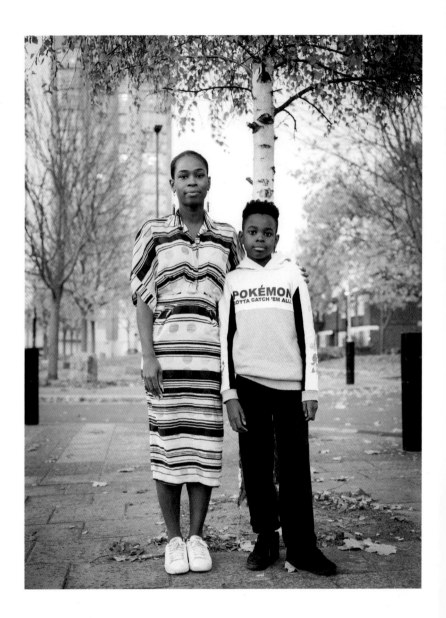

KHALIFA
(with Josiah)

I met my son's dad when I was 16 and in college. I wanted to fix him despite all of his shortcomings. We split up when I got pregnant at 24. He immediately went off and married another lady. I am a single mother now, thriving and enjoying life and embracing my beautiful son. I'm happy that I chose to have my child – and not a man.

I think that you should always follow your instincts. We women have intuitions. Don't ignore red flags and embrace loneliness because it's better to be lonely by yourself than be in a relationship and alone.

I've learnt that I don't need to wait for someone to come and rescue me like Rapunzel, stuck in a tower. I can let down my own hair and climb away.

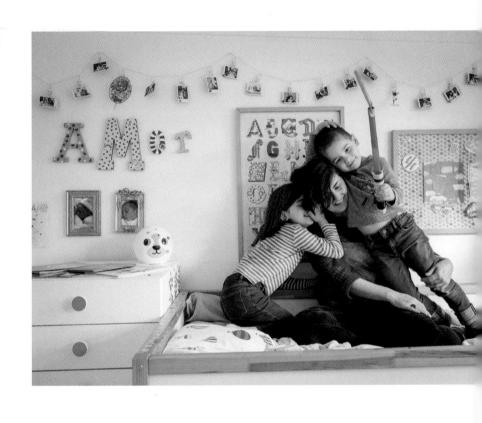

LUCIA
(with Lola and Bruno)

I'm from Uruguay. He's from Colombia. We come from different cultures, but most importantly, from radically different families, with different childhoods and life experiences.

For a long time, we lived largely independent lives and never fully experienced how fundamentally different we were. When we had our children, however, we realised that we couldn't understand, respect or be with each other any longer.

Failing at the relationship with the father of my children has been tremendously painful. At the same time, it's been the most transformational and affirming journey of my life so far. I'm a better mother, a more confident woman and a happier human being as a result. Hurt always comes with an opportunity. However paradoxical, I believe it has been a gift and a meaningful life lesson for our children. They're our lives and every day we work hard to give them a beautiful life. And they've learnt that if they aren't loved and accepted for who they are, they deserve more; they don't have to settle for less. Even if it's frightening, there's always the choice to give up and walk away.

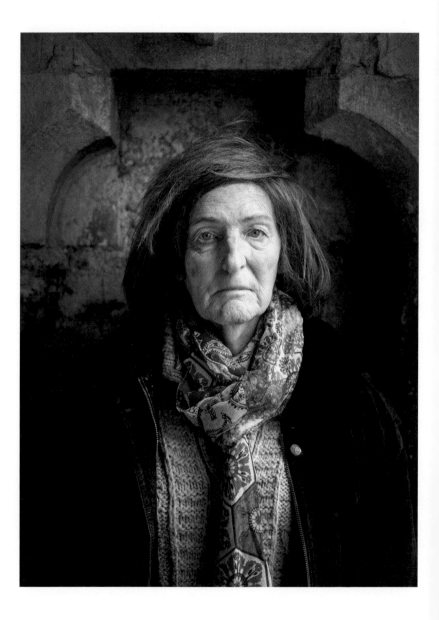

MIRANDA

I think I made the fairly common mistake of marrying somebody for sex rather than because I loved them, although I was, and am, very fond of her. And she's a very remarkable person. I drifted from her largely because of my work – and then in the course of spending nights in London, I developed a taste for gay sex.

My wife discovered that I was having gay assignments and confronted me. All the while I was professing to be a good, church-going, ethical businessman. I can't look back with any degree of pride or satisfaction on what happened, except that it did help me to the point where I could become Miranda.

I would love to be friends with her, but I don't think that she finds it at all easy to be in my company. Even less so now that I'm Miranda. I do know her new husband finds it extremely embarrassing, which I entirely understand. I'm not proud of the fact that we got to this situation. I would love to be able to talk to her again, but it's difficult. Maybe in the fullness of time, I'll be able to properly introduce her to Miranda.

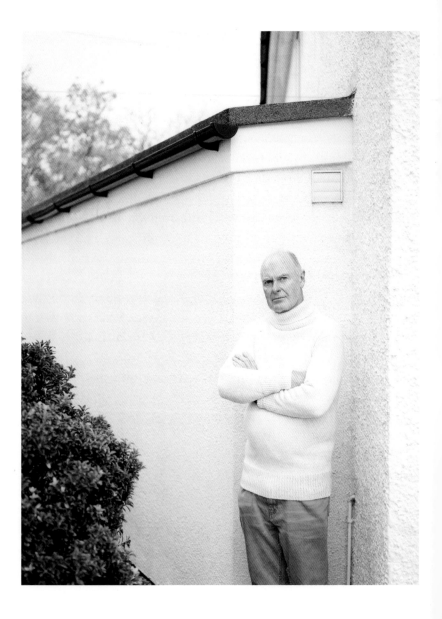

PHIL H

I got married when I was around 30 and then about a year after that, my first daughter Lucy came along, then a couple of years or so after that, my wife was pregnant again with twins. Unfortunately, George died the same day that he was born. I think if I was to look back on a cause of some of the conflict, it would come down to that day as much as anything. I was as shocked as she was over the death of my son, but I am very much a glass-half-full sort of chap and wanted to focus on the fact that we had a new daughter rather than that we'd lost a son.

As time went by, it was evident that we were going in different directions. I was either spending more time away from home or I wasn't trying too hard to come back. By the time both my children had gone off to university, my wife was at the stage of feeling that she didn't really need a husband anymore.

I'm sure that with perhaps more communication, we might have been able to sort it out. But she became more and more passive-aggressive. Not really mean as such, just very quiet. It made life less comfortable than it should have been.

I got a sense that towards the end she was being particularly awkward because she wanted me to initiate the divorce. It was as amicable as I might have expected really.

I'm probably one of those blokes that doesn't do a lot of talking about his emotions. It's no doubt an issue.

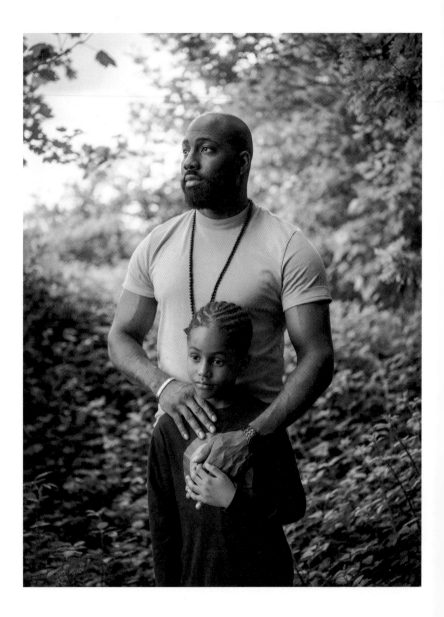

MICHAEL E AND ETHAN

MICHAEL: It's about a year and a half ago that we got divorced, we were married just over eight years. We ended up arguing over the smaller things.

Initially after we had separated, I arranged some counselling for us. We had a few sessions. Unfortunately, it didn't really help.

I feel very strongly against divorce unless it's completely necessary. Looking back, the issues that we had could have been worked through. So, I'm a huge advocate of counselling. I think premarital counselling is essential.

When I think about it practically, I tried my best. In hindsight there's many things I guess I could have done differently in the marriage, but overall, I try not to look back in regret.

ETHAN: I feel a bit sad. It's okay, but I think they shouldn't have gotten divorced.

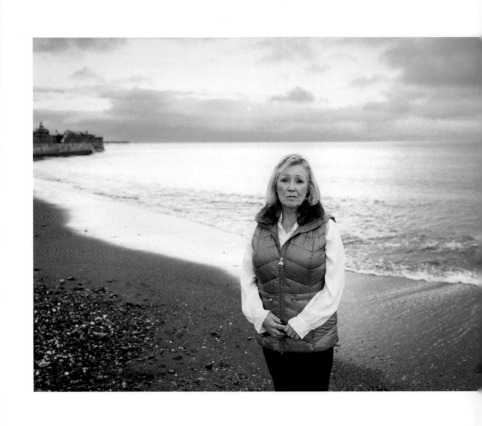

SARAH A

I'm a couple's therapist. With my clients I start by understanding each partner's perspective. Whenever anybody shouts or yells, it's often because they aren't feeling heard or understood.

A lot of couples will love each other but no longer know how to live together. They fall into a destructive and downward spiral where one will say something quite innocently, the other one will take it as an insult or a criticism and fire something back. One or both will then withdraw from the conversation. Criticism, defensiveness, withdrawal and contempt for each other are the main indicators of pending divorce. Learning to listen and understand rather than being defensive can reverse this pattern.

For my part, I was previously married to an alcoholic for twenty years. After many alcohol-induced incidents, the final straw was him accidentally setting fire to the house with our two children and myself in it. This set me on my current journey. The relationship I'm in now is the best I've ever had, much because of everything I have learnt about relationships.

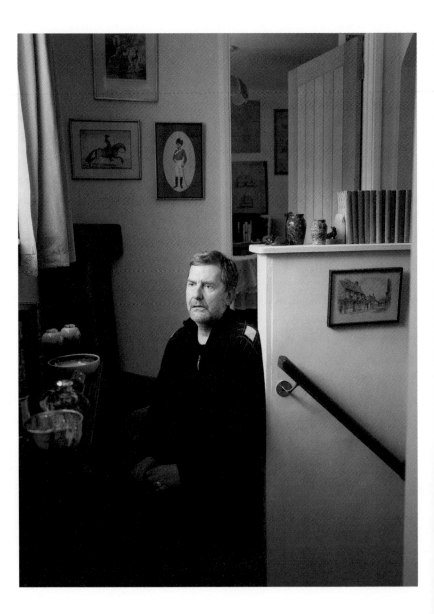

MICHAEL H

My parents' divorce changed everything for me. I was sent to a children's home and then to a boarding school while they were fighting it through the High Courts. It had an effect on my whole life; it affected my personality. With my mother's support I qualified in medicine, and I now work as a doctor, but I find it very hard to trust in social situations. Some people may survive their parents' divorce well enough, but the human body does different things to different people. Brains can and do get injured. I was diagnosed with acute PTSD and acute complex depression and trauma. I've had a very kind psychiatrist and that has helped; people need to tell their story to process it.

There were times when my mother, father and I were very happy, and I wonder if only we could have maintained that momentum. My father apparently said to my mother when they first brought me back from hospital: 'We three are now perfect, we can make it.' But his violent outbursts ruined that. I sometimes wonder if my parents had had a totally happy marriage, how would all our lives have turned out?

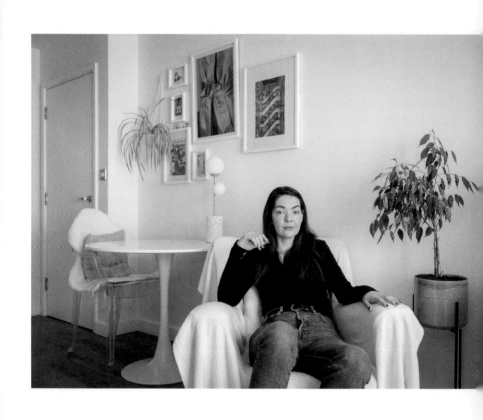

CHRISTINE

The only way I can describe divorce is that it's like having a family member disappear.

We tried relationship therapy but – frankly – it's a slap in the face because if you think you need an individual, a complete stranger, to sit there and facilitate a conversation between you and your partner, then you're already doomed.

Divorce takes so long to get over. The other day I was in Marks & Spencer, I went to buy his birthday card to post to him, and I suddenly burst into tears in the middle of the store.

It took me ages to even tell my hairdresser. There's a lot of small things that keep upsetting me; one of the things that absolutely broke my heart – and I know it's ridiculous – was having to change my Facebook status.

RUTH

I come from an orthodox Jewish background. I met my husband in Israel in 1990 when I was 24; we married three years later. He was gorgeous and it was lust at first sight – I guess I was shallow, but a relationship can't work without sexual attraction. He was different to other Jewish men. My orthodox parents would have disowned me if I'd 'married out', so my options were limited.

I knew that my ex was insecure and erratic. I should have run a mile. He was three years younger than me, and I thought he'd grow up and everything would be fine.

I realised I'd made a mistake soon after marrying him. He lacked the slightest ambition; he wanted to be looked after like a child. I tried very hard to make it work.

When our daughter was born in 1997, I was happy for a time and focused on her. Then I got pregnant again in 1999 and that's when I noticed a weakness in my limbs and difficulties with my speech. I was diagnosed with motor neurone disease in April 2000.

My husband abandoned me emotionally soon after. He hated my illness. That's when our marriage really started to break down. It left me heartbroken. I thought we'd married until 'death do us part'.

He couldn't cope and became verbally and physically abusive. When he left, saying gleefully 'I don't live here anymore', my son was too young to understand but my daughter was devastated.

I regret that our divorce was so acrimonious, especially for our children, but he behaved very badly. I've had a couple of relationships since, but I ended the last one of six years recently. I just want to be alone. I don't believe in marriage anymore.

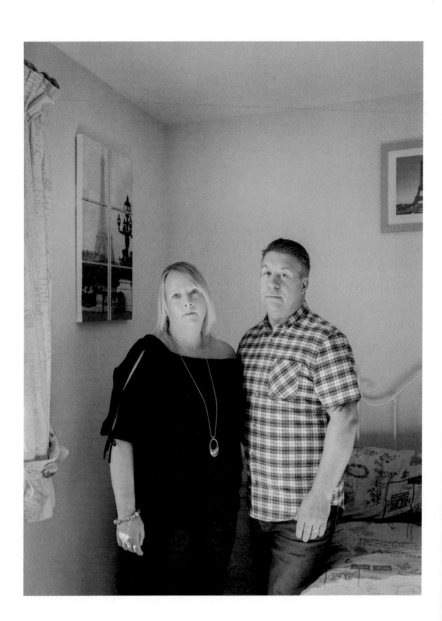

JEN
(with Davide)

I just remember being completely obsessed with him straight away, which sounds really weird, but I suppose that's what 15-year-old girls do, isn't it? We were still so young when we married for the first time.

I was a completely different person the second time. I honestly would never have thought in a million years that Davide and I would've got back together again after that painful divorce. But it's going so well. Expectations have changed, and we have grown a lot on both sides.

He's definitely my best friend. We don't have any secrets now. I heartily recommend remarriage to your ex.

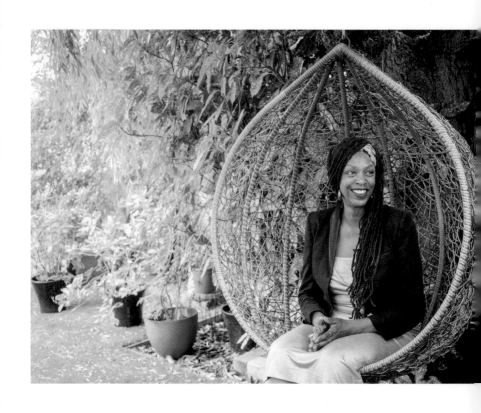

JACKEE

She found someone else and fell in love. She even began introducing her partner to friends and family. That's diminishing. That's a way of trying to eradicate somebody. I didn't find it easy. In life we haven't been taught how to end relationships well, to recognise that somebody can be important in your life but that it doesn't mean you need to stay with them.

It went to court. It was extremely messy. I don't know what advice my ex was given, but unfortunately it became quite a bitter war in terms of finances and property.

I decided that I was going to use all my savings to fight in the courts with a lawyer, but halfway through I decided to represent myself. It was a life-changing moment. It's one of the best things that I've ever done. I was really proud of how I stayed strong even though I was vulnerable and upset. I stood up to them and that will never leave me. It has helped me in so many other situations in my personal and professional life. I learnt that I could take care of myself better than anyone else can. I reconnected with my power and my authority. My ex thought I was a pushover; I proved her wrong. It was a tough lesson, but it was an invaluable gift in terms of what I've learnt about myself.

ANNA

I met my first husband in a psychiatric unit. We spent the whole evening chatting and we decided that we'd get married. Everyone thought we were crazy, which we probably were. We were together for seven years.

I met my second husband in 2010 and we married in 2012; slow for me. We had a big wedding. He is probably the best man I've ever met in my life. He's the kindest person alive. But as a partner, we just couldn't make it.

My mum says, 'You meet them, you fix them and then you move on.' She might have a point.

DAVE Z

We met when I was a student. She was an artist, which was very different from me and my family. There were clear differences in the way that our psyches worked, which was what we really liked about each other.

We eventually ended up having children – three fantastic girls. I was very keen to be fully involved in bringing them up and we had agreed before having them that we would both work part-time and share the load. The reality was very different. I was very much put in my place and was expected to be the breadwinner and to relinquish any say in the home. She didn't like me in the kitchen, she didn't like me choosing their clothes, and I found myself having to fight to have an equal status as a parent.

All the tension, it starts to build up, doesn't it? It got to the point where I couldn't cope any more, I was incredibly stressed, anxious and depressed. So, then it was a decision, wasn't it? It was stay and make it work, which I'd tried to do for many, many years and had not been able to do, or leave for the good of the children and my mental health. It was clear what needed to happen.

DAVID M

When she sat me down and we had the talk, the immediate feeling was relief.

A number of female friends have tried to pair me up with their best single friends, which is awkward because you don't want to disappoint anybody. But actually, I don't feel the need to get into anything. I've had the great love affair of my life.

We have season tickets at the football and we have carried on sitting next to cach other, which I think people find odd, but why not? There's no law I know of that says you have to hate your ex.

MIREILLE
(with Abuzer and children)

When we met, I felt an immediate bond – I don't know how else to describe it. There was a familiarity, a feeling of safety with him. Perhaps that was more pronounced by my being in a huge, strange city, in a foreign country as well.

But after our sons were born, cultural differences began to arise. In Turkey it is routine for boys to be circumcised and I simply couldn't and can't imagine imposing that on them. The gulf grew enormous. It felt like an impasse that expanded rather than abated through discussion. I wanted him to promise that the boys would be allowed to choose for themselves but the safety that I felt with him was completely undone. And so, I moved back to England, although I hoped we would find a way through.

He comes over from Turkey and stays with us so that he can be with the children fully in their own home. Over time we have rebuilt trust. The distance is hard, but they know he is there for them. That's more meaningful, significant and appreciated than I can say.

As the boys have grown, they've also become aware of different perspectives on circumcision, and their own, but it's not a focal issue or concern in their lives, thank goodness.

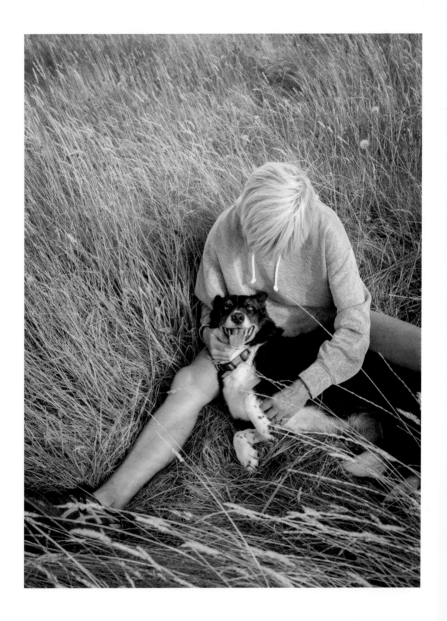

PENNY

We were married for twenty years. The divorce was extremely bitter. My husband became so nasty, so vile that he completely poisoned the children against me. He wouldn't let me speak to them. They would see me and run away. He weaponised them against me. They were in a complete state of turmoil. I'd arrange to pick them up from school and I would be sitting in the driveway for hours waiting for them to appear – only to discover that he'd taken them first. The perception that the children always end up with the mum isn't true.

It's hard to know the causes. There were warning signs, but I pushed them away. He was sent to boarding school when he was six. He was seeing a psychiatrist. I think he was depressed.

I remember at work, a few weeks before I instigated divorce proceedings, I had a meltdown in front of everyone. They recommended I call up the employment assistance helpline and I remember speaking to a man who asked, 'Do you still love him?' And I said straight out: 'I don't even like him.' I suppose it was over already by then.

RACHEL

(Penny's sister)

Since Penny's divorce, my relationship with her children has been non-existent. It probably started to deteriorate in the two years before they divorced and then literally it stopped. The children were very much under the influence of their father. Before she was divorced, we saw them regularly and had many happy times. The cousins were close.

My mother and father were incredibly sad that they didn't see them either. I remember a month before my father died, he'd had a note from one of the children, he was absolutely thrilled, and he kept it by his bedside.

I feel very cross that the divorce wasn't just something between him and Penny. He effectively stopped his children having cousins and stopped the loving support of grandparents, which is irreplaceable.

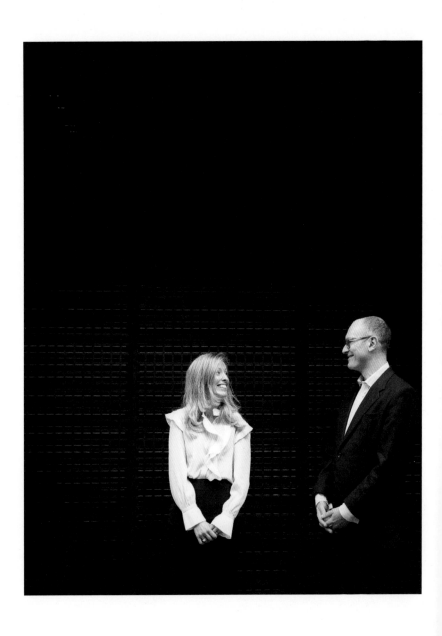

SAM AND HARRY
(divorce lawyers)

SAM: Any relationship is a choice. That's an active choice both people make, every day. If one, or both, get to the stage where that choice doesn't make sense anymore, it's OK to move on.

We need to shed the stigma of divorce. There are hard-wired beliefs that are wrong, such as that divorce is bad for children. In fact, it's much more nuanced than that. All the research shows that what can cause children (and their parents) emotional harm is exposure to entrenched conflict. That can happen in a bad divorce, but it can also happen in a deeply unhappy marriage. Divorce can be the healthy choice.

HARRY: I didn't start off as a lawyer wanting to do divorce, but I now love it. It's a huge privilege to be able to talk to people about such difficult things – and to try to help them out at possibly the worst moment in their life. There's an old canard that you see the worst of people when they're getting divorced, but I don't think that's true. What you see above all is pain. People are also capable of great generosity; they can continue to love and care for someone they no longer want to live with or who has betrayed them badly. It's remarkable.

In as far as I have a philosophy as a divorce lawyer, it's 'avoid court' and 'remember that there were reasons why you once liked each other.' Even after you separate, even after the ink is dry on the court order, you're still a family. And that's never truer than when you have children.

What people need are friends, then therapy. Then perhaps time. We're here as the last port of call.

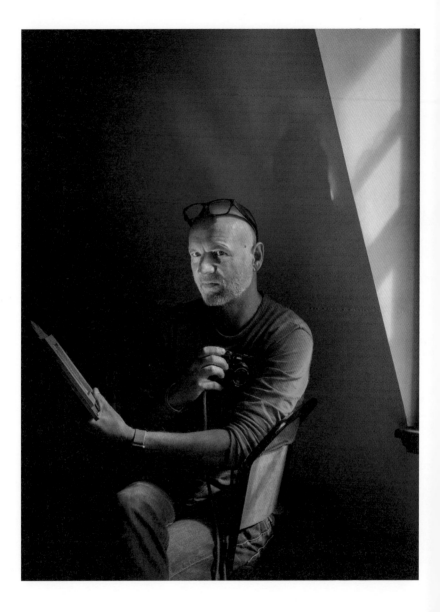

BENEDICT

She initiated the divorce, which on reflection was a good idea and I'm grateful she did. However, it got toxic quite quickly. A lot of it was fuelled by the lawyers, whom I can't find a kind word for. With their help, she served me up a long list of totally petty reasons why we should get divorced, like incompatible taste in music. It made no sense, but it would've cost me a lot more to contest. I don't know exactly how much she spent on lawyers, but I know how much I spent and assuming it was roughly the same amount, it would've been enough to pay for our son's entire university education or a small down payment on a flat or something.

We could have sat around a table and had a mediator sort everything out for £800. There was nothing complicated about our situation in the least. But maybe it wasn't perhaps ever really money we were arguing about.

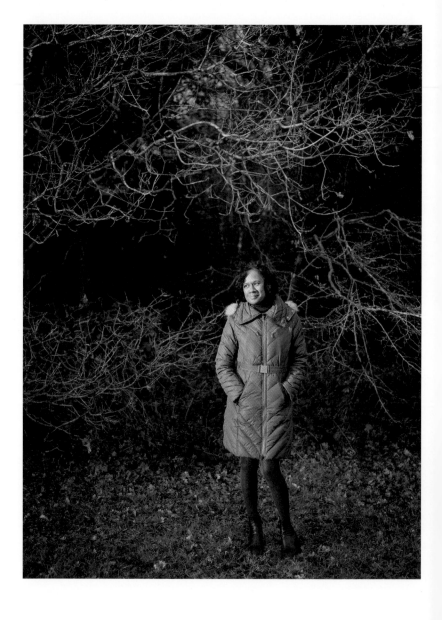

CAROLINE

I didn't foresee it happening. He decided he didn't want the marriage after fifteen years. As a follower of Jesus, there was only one place to throw myself; into my Saviour's arms. The big question was: would my faith carry me through the most traumatic season? Would it be the source of strength, the reality I needed it to be in the 21st century when so many shout, 'God is dead.'

In the Bible, Jesus says, 'My sheep hear my voice and recognise it.' I had recognised Jesus' voice for many years. Why would it be any different now? I cried, had sleepless nights, lost weight, and felt like I was in a never-ending pit. I also wrote poetry, created art, danced and recorded my God-conversations, which led me along my cathartic journey shouting, 'God is real,' even when things fall apart.

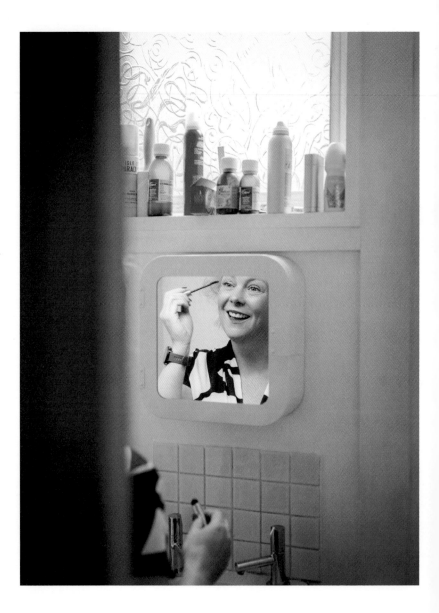

HELEN T

I suppose we all have ideas about how we might feel if we learnt our partner was having an affair. I thought it was going to be explosive; it was just the opposite. It was like a bucket of cold water had been chucked over me.

He didn't beg for forgiveness, he just looked like he'd been found out. Then I realised: 'Oh my god, she came to the gig, didn't she?' I'm a stand-up comedian. I remembered a Canadian woman a while back putting up her hand and saying, 'I've travelled from Canada, I'm your biggest fan.' It was a big moment in my career: an international fan! Far from it. I felt mocked and very humiliated.

I really wanted to get my wedding ring cut off. Someone said, 'Go to a fire station.' I was with two close friends and we marched off to the fire station and knocked on the door. I had four or five very hot firemen servicing me. I had one sawing off the ring, one with ice, another one lubricating my finger with Fairy liquid and then just another one holding my shoulders. It was this sort of massive symbolic gesture. One man put it on – and five men took it off.

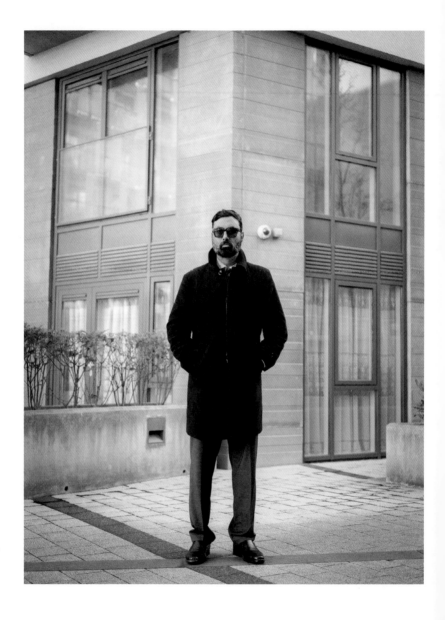

VIKAS

Arranged marriages are very common in India. I met my ex-wife only three weeks before my marriage. She lived in India; I was living in London. On my trip out there, I met nine girls who I had been chatting with and chose her.

Problems emerged early on. We had arguments between ourselves on the honeymoon and I even had arguments with her mum.

Divorce isn't common in India. A lot of miserable parents just sacrifice their life and focus on the children. I really didn't want to live like that. What messages are we sending to our child with that?

It was a very difficult court journey for me to be in my daughter's life, but I survived, and she now has both parents in her life. We happily co-parent although we have very different parenting styles.

I was quite open with her after the breakup – I'm going to try to meet as many women from other cultures as possible.

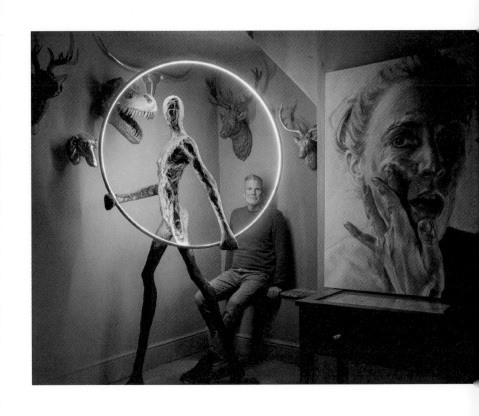

PATRICK

I've been married and divorced twice. One marriage lasted seventeen years, the other three years.

With the first one, after a while, I decided that I was deeply unhappy. My wife was devastated. She thought that we had the perfect marriage. But she was mostly focused on the children; that's what marriage was for her.

Five years after the divorce, I married again. She was very different. She wasn't family-orientated and didn't want children. I had been honest and said that I didn't want/couldn't father more children. But she changed her mind shortly after we married and started to want them very badly – I could not provide her needs. I went through a huge period of depression, the first time that I'd really been in a proper suicidal state.

Again, it was me who said that I wanted out and my wife was disappointed. She couldn't understand. She thought we had it all. In the end she said, 'I never want to see you, hear from you or have anything to do with you ever again.' I've respected that.

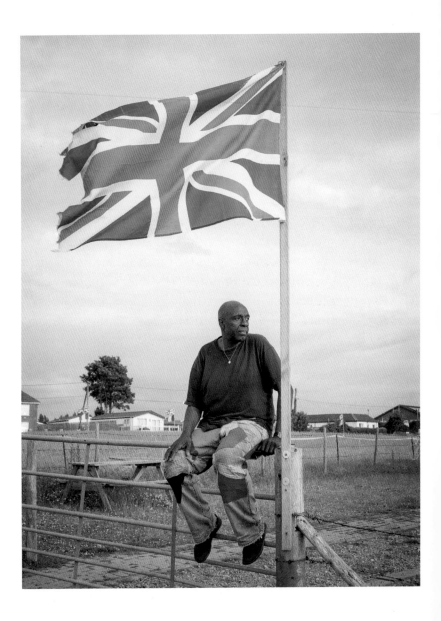

CEDRIC

The problem started with confidence. I was getting ever more of it. I was catapulted into this new environment, the art world, and the change was enormous. Suddenly there were dinners, parties, interesting people – it was dynamite.

Amelia was part of that world but we had three children and she was busy caring for them.

And I, for my part, was very bad. If you're going to have an affair and you don't separate first, you're a chicken. If you don't want to be with a person, do the decent thing and tell them before things start. Otherwise, you're lying to everyone, you're lying to yourself, you're lying to your wife and you're lying to the new person you're with. It's just indecent, basically. If your kids ask you, the only thing you want to be able to say to them is, 'I was decent.'

The divorce has been amicable. We're mates. I have my birthday parties in the garden with Amelia now. I would attribute it all to one fact: that I am to blame, and that I know it – that I take the responsibility. You can't say sorry enough. I apologise all the time. Almost every time I see her. If you're going to be an idiot, the best you can do is own it.

Poppy, Noah, Talulla, Bonnie x

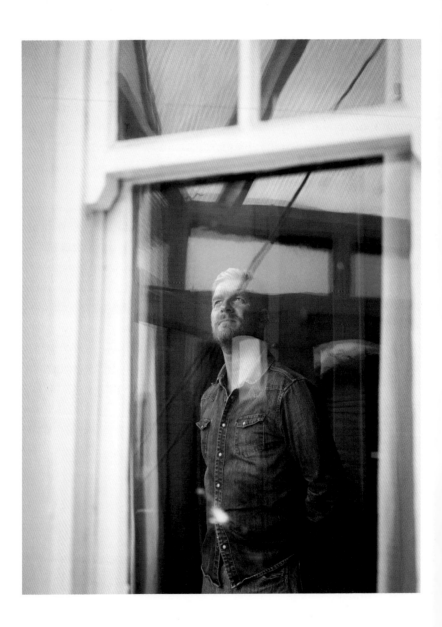

DAVID T

I was married for thirty years. She was an amazing mother, very committed to the kids. But she grew restless. She wanted to go dancing. At first, I didn't understand what it meant. I can't go clubbing until five in the morning, I like to get up early and go to a museum. Or to the sea.

Divorce is beyond awful to go through emotionally. Tougher than people can generally understand. You assume you know what it means, but you don't. When you've been together for so long, you become part of that person and they a part of you. This doesn't have anything to do with whether you happen to get on or not. It's to do with how much of your life you have been through together. Trying to find 'yourself' after they go is an immense task.

I'll always love her. The hate has gone. But I still feel a helplessness, a feeling of betrayal that can be so raw. I'd say to anyone who's going through a divorce, you've got to work on trying to let go of the hate.

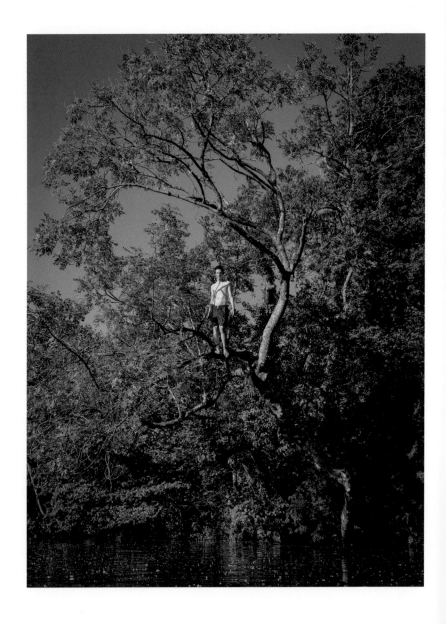

FLORIAN

(the photographer's son)

I was so surprised when I heard. I still remember it all exactly. I was playing a game with my brother – and Mum and Dad just pulled me out and said there was something important to say. I was annoyed at the time because I just wanted to keep on playing. Immediately after, I remember thinking I didn't really care at all.

I now certainly wish it hadn't been so quick. It helped to make it sink in I suppose, but it was really, really fast.

I think I'm happier now. I remember a lot of arguing.

Now we've got a dog. Or I do. And I don't know if that would have happened. The dog moves with me, so Mum and Dad each only have him fifty percent of the time.

I try to look on the positive side of things. Because Mum looks after me on her weeks, it makes that time more precious. You have a chance to form a stronger bond with both parents.

And if your parents have other relationships, you can meet interesting people. I like meeting new people. If your parent's other half has children, even if they're a bit shy, you can form deep friendships you wouldn't have had otherwise.

I'd say probably when I was little, all my friends' parents were together. Now seventy percent must be divorced. Nothing is certain.

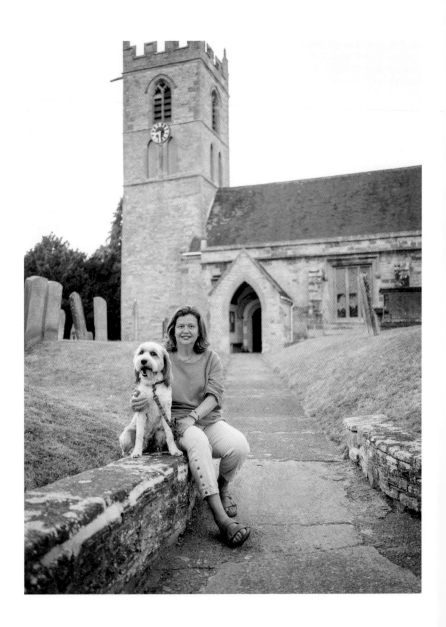

HELEN A

We had very different ideas about money. He worries about it a lot and I don't. It has to do with our backgrounds. My dad protected us, and I never had to give it a thought. He was terrified and got very frustrated by my spending. But I was a finance director so I needed a car and clothes that would fit.

We both came from families with dysfunctional marriages. We had no good role models or ideas – about communication or putting the other person first and not just carrying on.

I think he is a bit all over the place at the moment. He's even angrier, more frustrated and sadder than he was before. I do hope he finds somebody new that can make him happy.

KAJAL

My ex-husband and I met through a dating site. He wasn't the best communicator, he was a very quiet person, and I was always anxious that he wasn't really on my wavelength. I am an artist. Artists like to talk and philosophise about the world and he just wasn't really interested or inquisitive about those kinds of things. He was a take-things-as-they-are kind of person. I enjoyed his company; he had a really good sense of humour. But we didn't have any very deep and meaningful conversations, the kind that I like to have. I would often see his eyes glazing over when I'd been talking too long about ideas, but of course that's not the kind of thing I would have spotted when we would talk on the phone while we were dating.

My husband gave me all the material comfort that I needed. But he didn't really understand me as a person. I've still got so much respect for him, but he didn't see the artist in me.

KAY

We weren't talking properly; we weren't discussing where we were going or what we wanted. We were busy with everyday life.

One day, I found a list that he'd made in a little notebook of the things that he thought were wrong with me and our relationship. I found that shocking and painful. I think he was trying to make sense of his thoughts and he had been unhappy for a while.

It is important to find time to talk and really listen. Check in regularly. Don't assume your partner sees things in the same way that you do. Be creative with problem solving, work on it together and allow some room for 'give and take'.

PHIL M

She was diagnosed with health issues. I tried to support her as best I could.

I'm the legal guardian of her second child. The father's not really in the picture and because of her history of illness, social services wanted to take the girl away, so this is the best thing.

I suppose I am a bit of an unusual case in that I've managed to maintain a good relationship with her through all this. I think it's my temperament. None of us ever wanted this. She's not a bad person. I could look at it from a financial place and hate her guts, but I think, 'What's the point?' There's never any point harbouring a grudge. Children always come first.

ANUPAMA

I know that I did love him; I don't know if it was the same for him. But I do think his version of love is very different to my version of love. I think his idea of a relationship is: he's a provider, he's happy to look after you, but emotionally he will always be quite distant.

When Kate and I first started talking, I told her right away that, 'My ex and I are still living together,' and so there has never been a layer of deceit in all of this. My daughter loves Kate, she absolutely adores her. And Kate loves my daughter, too. Often, all of us go out together; it was my daughter's birthday recently and the four of us went for a meal and had a lovely time. We are a really strange family – but it works.

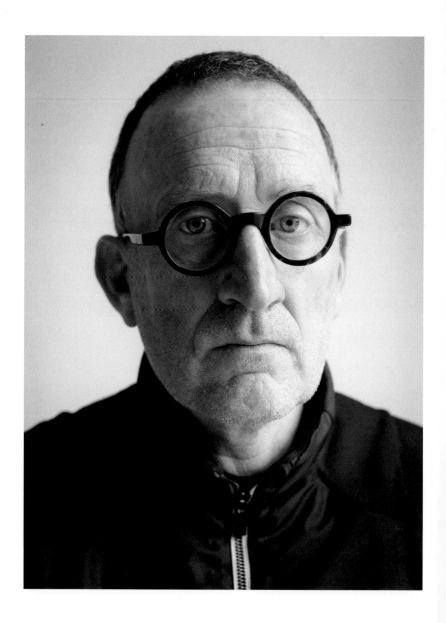

DAVID H

We saw them all the time, our kids played together. We were close. Of course, we knew that they weren't getting on as well as they might have been, but it was an enormous shock. I cried when they told me that they had decided to separate. We loved them and we cared deeply about the consequences for the whole family.

From a very early stage they made a huge effort to make the separation as amicable as possible. They accepted their differences and worked hard to hide any animosity from the children. I really admire that they are still on good terms fifteen years later and they both have great relationships with all of their children.

I doubt that any of my advice helped them, but I learnt a lot from them.

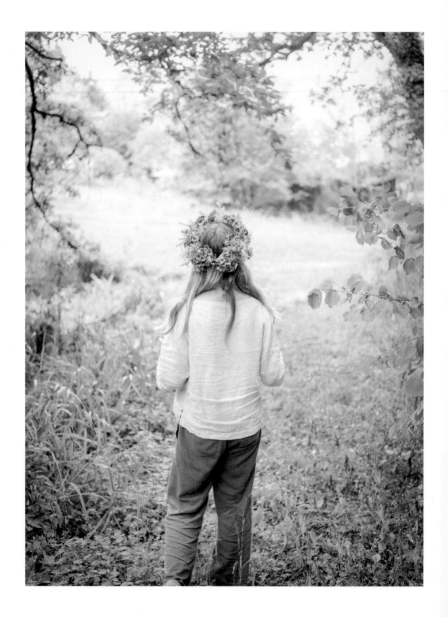

JILL

He was in the throes of a major nervous breakdown when he finally revealed to me that he had been having sex with men for the last thirty years – right from the beginning of our relationship.

He couldn't breathe, he seemed mad as a hatter. Because he was so poorly and needed help, I had to look after him; I loved him. There was no point in me going to bits as well. But it was very hard to take in. Here's this lovely guy who has been absolutely fantastic – a brilliant dad, a lovely husband, there was nothing wrong with our relationship. And suddenly this.

We're still a family; he's the father of my kids. The whole family chats once a week for an hour. But he seems quite different, he has changed in so many ways and, to a degree, the person I loved seems not to be there anymore. Maybe he never cared for me as much as I thought he did over all those years. He appeared in my dreams on a constant basis for years after we split. It can take a while for one's head to catch up with reality.

JENNY

In the early years of our marriage, he started drinking very heavily and spending a lot of money. Then he got very demanding. He would do things like wipe his finger across surfaces to check that they were clean enough. Even cooking Sunday lunch was incredibly stressful; there was so much pressure to make things tasty.

He grew very possessive. It was easier to stop talking about male colleagues or friends because he would accuse me of having affairs with them.

I left him about two years ago for about ten months, but I went back. I had to call the police when he smashed up my car. I still went back. He made a lot of promises to get support for his alcoholism. But nothing changed. So eventually I initiated the divorce.

Unfortunately, he continued to harass me and now I have a restraining order against him. He has finally recognised that he is an alcoholic and, most likely, has underlying mental health issues that can now be supported. I will never fully understand why he treated me so badly, but being out of his psychological control is a relief every day.

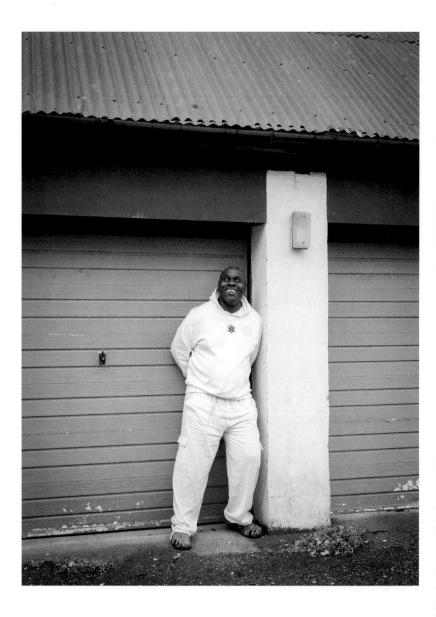

CHUKUMEKA

We were together for twelve years. She was white. If I'm honest, I had an underlying sense that I was trying to social climb. I was a black person in a predominantly white, public school, middle-class world. We were two ends of the spectrum. It was the establishment and I felt I had fulfilled my destiny. I suppose I was colonised.

My behaviour around my wife and her friends was not who I truly was. I was a caricature of myself. I am highly intuitive, but I was in a very intellectually pretentious world. I was a fake. I still struggle with my daughter Amanda now because some of the issues she's going through relate to my lack of self-awareness back then. It has taken me many, many years to slowly be comfortable in my own skin. We're getting there.

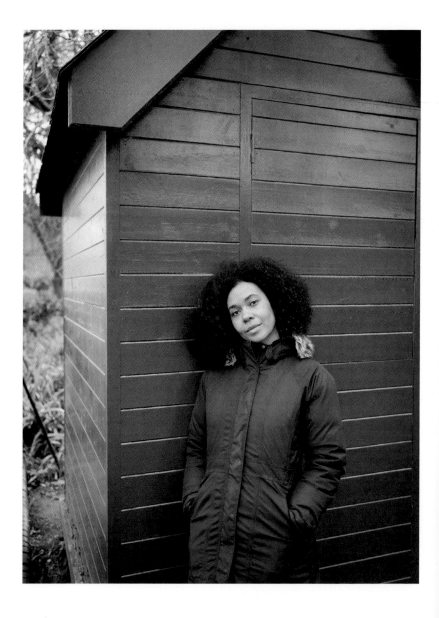

AMANDA
(Chukumeka's daughter)

The impact of my mum and dad's divorce has been huge.

My mum eventually remarried. But my stepdad struggled with me.

I often used to call my dad and beg him to help. I'd be like, 'Come and take me out of this situation.' But they stopped me talking to him. I'd try to run away. I think probably for my stepdad it was quite embarrassing; constantly having to get the neighbours to bring back your daughter.

I'm hyper-independent now. My uncle said to me at one point, 'I'll never forget a letter that you wrote to me when you were seven years old… it was like I was reading a letter from a forty-year-old.' These things make you grow up fast.

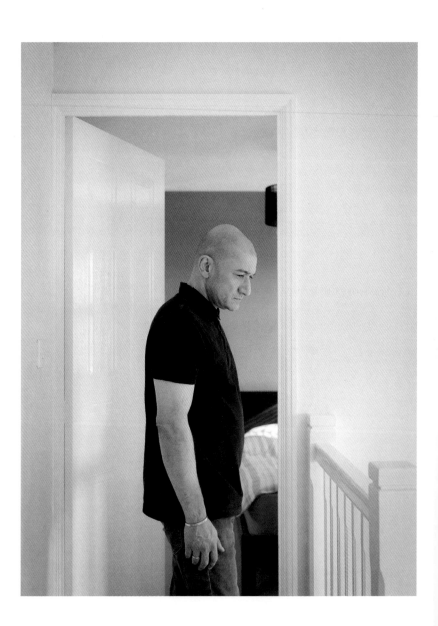

NAV

If the divorce is acrimonious, the children will grow up looking for new relationships in which conflict is normal, because that's all they know.

If you look at separation through the eyes of a child, it is nothing less than a tragedy. It's up to you how much you want them to suffer.

You have to realise that they are not your property. There is a great poem by Khalil Gibran called 'On Children' – it's in the book *The Prophet*. In it he says, 'your children are not your children'. There is everything in that line.

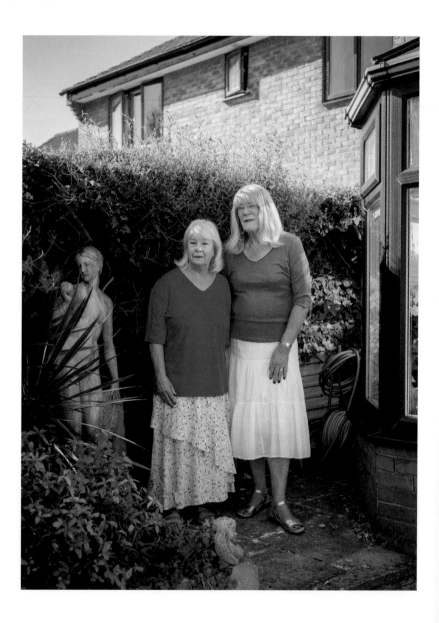

BARBARA
(with Jane)

We were together for eighteen years. But it wasn't a particularly good marriage. I think probably when I met the person who is now Jane, it made me realise that things could be an awful lot better.

I knew Jane for about nine years in the male persona before she came out to me and confessed that she would really rather not be that person.

There are elements of losing a person, but the same person is still there. Maybe to some of our friends, maybe to the rest of the family, it was a bereavement, but to me it was about becoming more real. I love Jane totally.

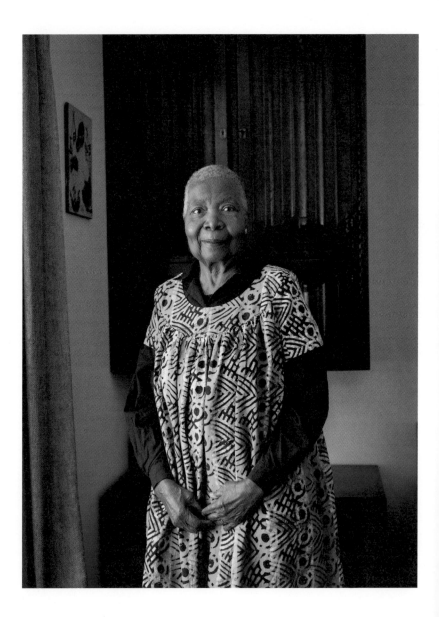

MARY

We had four children in nine years. In Ghana they see it as the woman's job to get on with it, whatever the circumstances. I tried to make it work but he was an irresponsible man.

When I got a teacher's job, I knew I had enough money to separate.

In Ghana, women are very strong. My grandmother was a role model. She didn't see anything as a problem. If my temperament had been different, things would have been different of course, but I just got on with it. I didn't expect to fail – and I haven't.

With divorce, attitude is everything. There's no need for acrimony between the two parties.

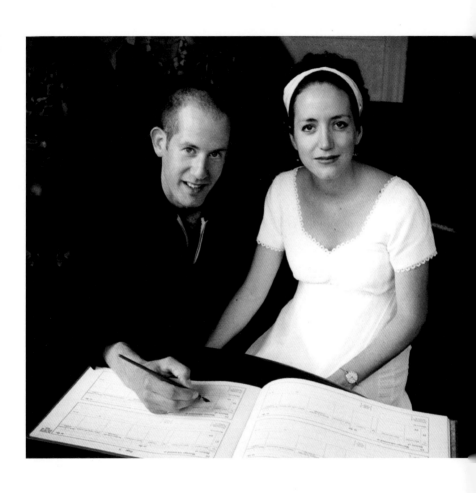

HARRY BORDEN
(with Jane)

'Is there someone else?' I said it without ever thinking there might be. Two actors in a play, it seemed the logical next line. Scripted by our own parents' dysfunction, it was inevitable that we would part. We'd been an efficient team; three healthy children, a big house. But if our relationship was a garden, it was now tangled with weeds, a neglected space. We had lost the ability to talk.

At first, I was numb, but as the months passed, I began to see the complacent facade I had constructed. Over time I started to re-establish friendships, change my priorities around work and family, cede control and listen. After an intense ten-day meditation course, I saw that marriage is just a set of ideas we have about ourselves. Nothing really bad had happened. Nobody was terminally ill. I wasn't losing her. Our relationship was just being reconfigured. As Keith (p.48) said, 'It's time for you to have some fun, kiss another woman, fall in love again...'

We would divide our assets fifty-fifty. No lawyers. I could see that the best way to win her back – or not win her back and be content – was to accept that if you love someone you want them to be happy, even if their plans don't involve you. Almost immediately, and maybe for the first time, a friendship began to blossom. United in concern for our three children, we were now pulling in the same direction.

Jane and I were so different when we married in 1995 and it's strange to contemplate the distressed, lost souls we became. Now she's among my closest friends; the people I phone when something big happens. I'm so lucky to know her. It astonishes me that we have reached this place. And yes, I did fall in love again...

PHOTOGRAPHER BIOGRAPHY

Harry Borden is an acclaimed British portrait photographer. He has exhibited widely, including the solo show 'Harry Borden on Business' at the National Portrait Gallery in London in 2005. Previous publications include *Survivor: A Portrait of the Survivors of the Holocaust* (2017) and *Single Dad* (2021).

harryborden.com

The photographer wishes to thank: all of the book's subjects, as well as Jane Borden, Abbie Trayler-Smith, Polly, Fred, Oscar and Florian Borden, Phoebe Adler, Michael Hope, David and Andrea Humphries, Annie and Al Murphy, Marie and Jackie Luke, Jon Hempstead, Jennie Baptiste, Kajal Nisha Patel, Bill Coles, Michael Fairfax, Mike Button, Mireille Thornton, Colin Strong, James Brown, Martyn and Mary Collins, Nikki Kemp, William Leith, Mike London, David McHugh, Leon Miller, Sean Oades, Katharine Price, Madeleine Sanderson, Justine Wall, Stuart Weightman, Kevin Whitchurch, Debbie Wint and, finally, Kay Layden, who brought sunshine into my life.

THE SCHOOL OF LIFE

RELATIONSHIPS

Learning to love

The School of Life: Relationships

Learning to love

**A book to inspire closeness and connection, helping people
not only to find love but to make it last.**

Few things promise us greater happiness than our relationships – yet few things
more reliably deliver misery and frustration. Our error is to suppose that we are
born knowing how to love and that managing a relationship might therefore be
intuitive and easy.

This book starts from a different premise: that love is a skill to be learnt,
rather than just an emotion to be felt. It calmly and charmingly takes us through the
key issues of relationships, from arguments to sex, forgiveness to communication,
making sure that success in love need never again be just a matter of luck.

UK: 978-1-912891-97-9
US: 978-1-915087-13-3
£9.99 | $14.99

Confidence in 40 Images

The art of self-belief

An inspiring, curated selection of forty photographs and artworks with accompanying essays examining the skill of confidence.

The difference between success and failure often comes down to an ingredient that we are seldom directly taught about and may forget to focus on: confidence.

What makes one life cheerful, purposeful and energetic and another less so may have nothing to do with intelligence or qualifications; it may simply be bound up with that buoyancy of the heart and mind we call confidence.

Here is a supreme guide to this fatefully neglected quality; a series of encouraging essays that jog us into a new and more fruitful state of mind. The images that accompany the text are included to ensure that we aren't merely intellectually stirred to change our lives, but that we are also given the best kind of visual assistance.

We learn why we should dare to try, why the past doesn't have to dictate the future, why we can alter the way we speak to ourselves and why there are so many reasons to keep faith with our most ambitious aspirations.

ISBN: 978-1-915087-30-0

£15.00 | $19.99

Art Against Despair

Pictures to restore hope

**An inspiring selection of images offering us hope and comfort,
reminding us that we are not alone in our sorrow.**

One of the most unexpectedly useful things we can do when we're feeling glum or
out of sorts is to look at pictures. The best works of art can lift our spirits, remind
us of what we love and return perspective to our situation. A few moments in front
of the right picture can rescue us.

This is a collection of the world's most consoling and uplifting images,
accompanied by small essays that talk about the works in a way that offers us comfort
and inspiration. The images in the book range wildly across time and space: from
ancient to modern art, east to west, north to south, taking in photography, painting,
abstract and figurative art. All the images have been carefully chosen to help us
with a particular problem we might face: a broken heart, a difficulty at work, the
meanness of others, the challenges of family and friends ...

We're invited to look at art with unusual depth and then find our way
towards new hope and courage. This is a portable museum dedicated to beauty and
consolation, a unique book about art, which is also about psychology and healing:
a true piece of art therapy.

ISBN: 978-1-912891-90-0

£22.00 | $32.99

A Voice of One's Own

A story about confidence and self-belief

**A therapeutic novel that teaches us about our own emotions
through a young woman's journey of self-discovery.**

This is a novel with a striking mission at its heart: not just to tell us a story, but to show us – through the example of one life – how we might change our own.

The novel introduces us to Anna, a kind, inspiring, thoughtful but modest and self-questioning person, in whom we might catch echoes of ourselves. Life has been hard of late for Anna: her job is putting her under extreme pressure, her relationship is lacking the support she craves, her parents have saddled her with a complicated emotional history. And yet she is determined to progress and liberate herself from her inhibitions.

In a style that's brief and poignant, accompanied by lyrical and thought-provoking images, we follow Anna as she unpicks the roots of her self-suspicion and discovers something we all deserve but have so often been denied: a voice of our own.

The novel amounts to a bold new kind of fiction: one that doesn't only entertain and move us, but along the way, almost without our noticing, educates and enhances us – nudging us towards new possibilities and courage for ourselves.

ISBN: 978-1-915087-26-3

£15.00 | $19.99

The School of Life publishes a range of books on essential topics in psychological and emotional life, including relationships, parenting, friendship, careers and fulfilment. The aim is always to help us to understand ourselves better and thereby to grow calmer, less confused and more purposeful. Discover our full range of titles, including books for children, here:

www.theschooloflife.com/books

The School of Life also offers a comprehensive therapy service, which complements, and draws upon, our published works:

www.theschooloflife.com/therapy

THESCHOOLOFLIFE.COM